# Women's College Education in the Past Two Centuries

## John J.W. Rogers

PublishAmerica
Baltimore

Hardcover 978-1-4560-7243-8
Softcover 978-1-4560-7242-1
PUBLISHED BY PUBLISHAMERICA, LLLP
www.publishamerica.com
Baltimore

Printed in the United States of America

# Table of Contents

# Foreword

## An acknowledgment and why I wrote the book

I am a geologist. After receiving B.S. and PhD degrees at an all male school, I started my career when geology was mostly a male profession. The school is now coeducational, and young geologists are mostly female.

My first teaching job was at Rice University, which was technically coeducational but had no residential facilities for women on campus. The situation began to change when Rice developed residential colleges. Students were assigned to one college when they entered and remained in that college through all four years of their program. Each college had a college master who lived with his family in a house next door to the college and was available to students at almost any time.

From 1966 to 1971 I was the Master of Brown College, at that time a college for women. Brown and all other Rice colleges are now coeducational.

After being launched into the world of in women students, I maintained that interest at Rice and, later, when I was on the faculty of the University of North Carolina at Chapel Hill. It seemed natural, therefore, that I devote a book on the history of American colleges to their adaptation to women students.

9

Let me thank the members of Brown College in the late 1960s for inspiring this book forty years later. You are wonderful people. I learned so much from you, and I hope you learned something from me.

## Definition of male culpability index

Each of the following chapters ends with my opinion of the situation discussed in the chapter. My opinion is summarized by assignment of a "male culpability index" that ranges from 0 (low) to 10 (high) and shows the extent to which I feel that men were responsible for problems faced by women.

# 1. The Bible, Kitchens, and Babies
## (colonial America to the early 1800s)

*To make women learned and foxes tame has the same effect — to make them more cunning.* said King James I when he succeeded Queen Elizabeth I to the throne of England in 1605.

John Adams said he laughed in his letter to his wife Abigail on April 14, 1776. His letter was in response to Abigail's letter of March 31, 1776, in which she said that that women in the independent new country would not abide by the laws and were ready to rebel if women were not given more authority. (This information is from the website of the Massachusetts Historical Society atwww. masshist.org/digitaladams.)

Well, now! Here was a threat that the men writing the Declaration of Independence would not only have to get rid of the English but then have to handle an insurrection by American women.

None of the men seemed worried. They were following a long tradition of putting women in submissive roles. For example, English "man of letters" Samuel Johnson seemed to be afraid of women in the 18th century. Reflecting on women's ability to bear children and their innate intellectual gifts, Johnson wrote "Nature

has given women so much power that the law has very wisely given them little."

Was it men's fear of women that made men embrace a biblical view of women's subservience? That made college education of women impossible in colonial America? Was it fear that made even high school beyond all but a very few women? Was there some other reason why men wouldn't allow this education? Could men have taken over some of women's traditional work and given their daughters and wives an opportunity to go to school? Were there difficulties that no one could do anything about?

This chapter explores these questions, and the title shows three of the problems. The bible because it promoted the idea that women were responsible for sin and should be subordinate to men. Kitchens because women had to spend so much time at home in a whirlwind of duties that included preparing food for their families. Babies because women began to have children in their teens and commonly had at least six children — or more — during their lifetimes.

We continue with establishment of the earliest colleges in America, the effect of the American Revolution on women, and early efforts to provide some form of education for women. We finish with my opinion by asking whether we should criticize the founders of early American colleges for not including women.

## The Bible
The idea that women are inferior to men and are the source of sin is laid out in several verses in Chapter 3

of Genesis. Let's cut through the biblical verbiage and summarize them:

God told Adam and Eve that they could eat the fruit of every tree in the Garden of Eden except for the tree in the middle of the garden. It was the tree of the knowledge of good and of evil, and Adam and Eve weren't supposed to know this.

A talking snake came to Eve and said she could eat the fruit.

Eve said "Okey Dokey" and ate the fruit and gave some to Adam.

God got mad. He told Eve that childbirth would be painful, but she should obey her husband and have as many children as Adam wanted. God told Adam that his soft life in Eden was over, and he would have to work hard to raise food.

Then God threw Adam and Eve out of the garden to the "east of Eden" and set a guard at the gate to make sure they didn't get back in.

Wow! That's one sneaky snake and one gullible gal. Or was Eve just bored with Eden and thought she should put a bit more excitement in her life? Who knows? The important point is that a lot of men took this story seriously, perhaps because it reinforced their fear of women.

The view of the inferior position of women was made clear at numerous other places in the bible. Examples include:



"Let the woman learn in silence with all subjection. But I suffer not a woman to teach, nor to usurp authority over the man, but to be in silence.'" (1 Timothy 2).

"Wives, submit yourselves unto your own husbands, as unto the Lord. For the husband is the head of the wife, even as Christ is the head of the church: and he is the saviour of the body. Therefore as the church is subject unto Christ, so let the wives be to their own husbands in every thing." (Ephesians 5)

How did this view of women get into the bible? The quotations above are from the King James version of the bible. In 1605, King James I of England commissioned "That a translation be made of the whole Bible, as consonant as can be to the original Hebrew and Greek; and this to be set out and printed, without any marginal notes, and only to be used in all churches of England in time of divine service." The purpose was to reconcile the myriad versions of the bible then in circulation and decide what the original writers of the various books really meant.

Yeah, sure. Deciding what the original writers meant was difficult because no one knows who the original writers were. Furthermore, there were Hebrew versions of the Old Testament, Greek versions of the Old and New Testaments, and Latin versions of everything.

No problem for King James' forty four translators. All of them were men, and they faithfully included the philosophy of women's inferiority and responsibility for sin. The King James Bible was finally published in 1611 and has remained a standard to this day.

This concept of women was strengthened by some of the men who helped establish the Christian Church. In the 4th century, St. Jerome said "Woman is a perilous object." (In all fairness, we should note that this "saint" also hated Jews.) In the 13th century, Thomas Aquinas said that woman was "defective" and useful only for procreation.

The dismal view of the position of women was reflected in English common law. Women became the property of their husbands when they married. Until the late 1800s all of the property that women owned before marriage also became their husband's property. Theoretically, a husband owned even the clothes that his wife wore, and he could send her away with nothing if she disobeyed him.

A further problem for women was the English policy of "fee tail" for property. Property was commonly "entailed" so that it passed to the control of the nearest male relative when a husband died, and courts would search for the closest male relative — possibly a nephew — if the family didn't have a son. When this man was in control, the widow could no longer remain in the house she shared with her husband without the man's permission. (See the novels of Jane Austen for the effects of entailment.)

Fortunately, entailment of property was never firmly established in America. Men owned their property in "fee simple" and could dispose of it in their wills to anyone of their choice. Most colonies also had laws that required that widows receive enough resources to maintain themselves and their children.

# Kitchens

It is easy to romanticize the "simple life" of colonial Americans. Sometimes we go on a camping trip in order to do this. We pack the car with a tent, sleeping bags, a kerosene stove, battery-powered lantern, cooking gear, eating utensils, and a box of canned food. We can also include a box filed with ice, meat, and canned beverages of our choice. And, oh yes, the bug spray.

We drive to the campground, set up the tent, fry some burgers, boil vegetables, pop some brews, and settle back for dinner. After dinner, we use the flush toilets in the restrooms and curl up in our sleeping bags. Isn't the simple life wonderful!?

Reality in colonial America was very different. Without modern conveniences, there was a lot of work to do in kitchens. Except for houses of very wealthy people, most colonial homes had only one hearth and one chimney. Placing the hearth in the center of the house kept the whole house reasonably warm (if people wore sweaters). The hearth was part of the kitchen, and women were in charge of this area and all of the activities connected with it. These women were wives in most families, but any family wealthy enough to consider sending a child to college would have had servants that worked under the supervision of the wife.

The wives and their servants had a staggering number of duties at their hearths. Early in the morning, women had to start a fire by striking flint against steel and lighting easily flammable tinder. Porridge and stews were prepared by boiling in a pot. Bread was baked in an oven that could be heated on all sides. Meat was

grilled in a pot or on a spit, and women made candles by collecting fat rendered during cooking, then pouring the fat into tapered molds, and letting the fat cool around a string or something else that formed a wick.

Women could not prepare meals unless they helped produce the food that was served. Pork came from a pig that women fed until they or their husbands slaughtered and butchered it. Most farms kept chickens, using the roosters for meat and the hens for eggs. Women were usually responsible for feeding the chickens and collecting eggs.

Milk had to be fresh in colonial time. Women who lived on farms did most of the milking, and women who lived in towns could buy milk from merchants. Women had to churn milk into butter at home.

Vegetables were available only because of women's labor. Both on farms and in cities, women were expected to raise a vegetable garden that included beans, squash, herbs, lettuce, and root vegetables such as carrots. Women were expected to help in the fall with the harvest of corn and other grains that had been farmed by their husbands.

In addition to preparing food to be eaten immediately, women had to help preserve it for future consumption. Women put potatoes, carrots, turnips, and onions into root cellars and preserved fruit by boiling it and then sealing it in glass jars with paraffin. Paraffin seals also preserved cheese. Women preserved vegetables by pickling them in vinegar.

All of the activities in a kitchen required water. Even in cities, however, piped water was not available until about the middle of the 19th century. In order to get

17

water, women had to pump a family well, or go to a public well.   Then they had to carry water in pails back to their houses and store it in a barrel or some other cistern.

The difficulty of getting water meant that it had to be used sparingly.  Drinking and boiling food were essential, but cleaning pots, dishes, people, and clothes were optional.   The lack of interest in cleanliness had been shown by a statement by Queen Elizabeth I of England — *"I have a bath every week whether I need it or not."*

In order to wash anything, women had to make soap. Women made lye by dripping water through ashes left by burning hardwood trees.  Strong soap ("grandma's lye soap") consisted of lye mixed with animal fat (tallow), and soft soap consisted of lye mixed with vegetable oils.

After women made the soap, they washed clothing by rubbing the clothes in warm soapy water, taking the dirty water outside to throw away, adding rinse water, throwing that away, running the clothes through a hand wringer, and hanging them to dry on a line outside the house or inside the house in bad weather.  When the clothes were reasonably dry, women could iron them.

Running water is also essential to sanitation, and in its absence there were two ways of disposing of  human waste.   The preferred method was outhouses, which were used even in cities.  Another method was to use a "chamber pot," which could be covered by a lid until women could take it outside and throw the contents onto their farm or a city street.

Many of women's activities around the hearth concerned clothing.  They spun wool and cotton into yarn, sewed and repaired clothes, knitted sweaters

and blankets, and went through the tedious process of separating flax from plants in order to make linen.

# Babies

In colonial America, babies weren't supposed to arrive until nine months after the wedding. Both men and women were presumed to be so much in control of themselves that they could check out their compatibility by "bundling" before marriage. Bundling was the practice of a prospective couple sleeping together without having sex.

Right! And anyway. who's counting?

Married or not, most women began to have children soon after they reached puberty. This meant that they were fertile from their middle teens for about 30 years. Although lactating mothers are slightly less fertile than women who are not breast feeding, many women did become pregnant within a few months after the birth of their last child. Thus a woman could potentially bear 25 to 30 children, and a few women did.

The consequence was that a typical woman had an infant to care for throughout much of her life unless she lived into her fifties. Most women didn't live that long, partly because so many died in childbirth. Largely because of these deaths, the average number of births per woman was about 6. Many men married again after their wife died, thus ensuring a continued sequence of young children in the home.

Women began to get help in their homes as their children grew older. Girls had to be trained to be wives and mothers, and this required them to learn to cook,

clean, and sew. Thus the girls became real helpers to their mothers when they reached the age of about ten.

Some colonial women did not accept their fate of repeated motherhood. Some remained unmarried and made their living running boarding houses or working as servants or seamstresses. Some married women in relatively wealthy families could convince their husbands to use condoms made of lambskin or animal intestines. Condoms are named for Dr. Condom, an English physician, although no one is sure that he existed, and some type of condom had been in use for hundreds of years before his alleged life. If women did become pregnant, they could try to abort the fetus with either drugs or external methods. One drug was the root of male fern ("worm fern;" *dryopteris felix-mas)*. It was sometimes called the "prostitute root." External methods involved exercise, including lifting heavy objects and climbing trees.

## Beginning of college education in America

Although John Harvard was a Puritan clergyman, he saw nothing wrong with making money. He may have preached "fire—and—brimstone" sermons, but he apparently didn't believe the biblical injunction against becoming rich. Thus it was that John Harvard had land and money to bequeath to a newly formed college in Cambridge, Massachusetts, in 1638.

A major purpose of this college was to train clergymen and teachers to teach children to read the bible and save their souls. One indication of this concern was the enactment of "Ye Olde Deluder Satan" Act in 1647,

which established grammar schools throughout the Massachusetts Bay Colony.

Who would teach these children to push Satan aside? Certainly not women, who were responsible for sin. In order to battle this sin, Harvard College originally enrolled nine students under the direction of one master. The master and all of the students were men. Women students did not arrive on the campus until Harvard established coordinate Radcliffe College in 1879 (Chapter 3).

The second college in the American colonies was established more than 50 years after the founding of Harvard. In 1693 the King of England provided money and profits from the sale of tobacco to countries other than England to support a new college (from www. wm.edu). This support enabled William and Mary to open its doors to Native American young men and the sons of the colonists. The purpose was to teach "Divinity, Philosophy, Languages, and other good Arts and Sciences." Obviously nothing there for women.

Several other colleges were chartered in the colonies before the Revolution:

The Collegiate School (now Yale) in 1701 "wherein Youth may be instructed in the Arts and Sciences [and] through the blessing of Almighty God may be fitted for Publick employment both in Church and Civil State." In 1718 the school was renamed "Yale College" in gratitude to the Welsh merchant Elihu Yale, who had donated the proceeds from the sale of nine bales of goods together with 417 books and a portrait of King George I (from www.yale.edu).;

The Academy of Philadelphia (now University of Pennsylvania; www.upenn.edu); in 1740; The four colleges then in existence in the English colonies Harvard, William and Mary, Yale, and Princeton — were all schools for educating the clergy, but Benjamin Franklin wanted a school that would prepare students for business and public service. Franklin chose Reverend William Smith as Provost. Smith was so dedicated to the school that, "when he was thrown in jail for protesting against the politics of the popularly-elected Provincial Assembly, he continued to teach his classes from the Old City Jail."

Kings College, now Columbia in 1754; "In July 1754, Samuel Johnson held the first classes in a new schoolhouse adjoining Trinity Church, located on what is now lower Broadway in Manhattan. There were eight students in the class. At King's College, "the future leaders of colonial society could receive an education designed to "enlarge the Mind, improve the Understanding, polish the whole **Man**, and qualify them to support the brightest Characters in all the elevated stations in life." (from www.columbia.edu; emphasis is mine). Barnard, a coordinate college for women was established in 1889 (Chapter 3).

The College of Rhode Island (now Brown); www. brown.edu) opened in 1764 as a men's school. It was renamed Brown in 1904 because of a $5,000 gift from Nathaniel Brown, an alumnus. Pembroke, a coordinate college for women, was established in 1891 (Chapter 3)

Queens College (now Rutgers (ruweb.rutgers.edu) opened in 1766. The charter was signed by William Franklin, the last Colonial governor of New Jersey and

Benjamin Franklin's illegitimate son. The college was named in honor of Charlotte of Mecklenburg, consort of King George III.

Dartmouth was originally established in 1769 "for the education of local Indians and also of English Youth and any others." (from www.dartmouth.edu)

Hampden—Sydney was founded in 1775 and is still a men's school.

## Effect of the American Revolution

The push to establish colleges was interrupted by the Revolution but followed rapidly at or after the end of the war in 1783. By this time, Americans had the opportunity to learn more about the abilities of women. Women had taken over many of men's jobs when men were in the Continental Army. A few women had even fought with the troops. The most famous of them was Mary Hays McCauly (better known as Molly Pitcher). At the battle of Monmouth on June 28, 1778, she carried pails of water to troops and also to pour on guns to cool them. And when one of the artillery pieces needed another person to manage it, she rammed shells into the gun. George Washington later appointed her as a non-commissioned officer.

So, did the colleges established after the war admit women? No, not one. All of the schools were for men only, and we describe their conversion to coeducational more than a century later in Chapter 3.

The Carlisle Grammar School in Carlisle, Pennsylvania, was established in 1773 and expanded into Dickinson College in 1783 (www.dickinson.edu). The main leader in the establishment of the college was

Benjamin Rush, who was an opponent of slavery and a proponent of equal education for women. He believed that Dickinson College would "provide a steady source of citizen-leaders who would realize, in perpetuity, the hard-won revolutionary values and principles." Leaders? That meant men, not women. Dickinson didn't accept women until 1884 despite the claim that Benjamin Rush was a proponent of equal education for women. (from the website www,dickinson,edu)

Union College (www.union.edu) was chartered in 1785 with the motto "Sous les lois de Minerve nous devenons tous freres," ("We all become brothers under the laws of Minerva" — Minerva was the Greek goddess of wisdom). Brothers, not sisters, and the school remained all male until the first class of two dozen women arrived as transfer students in 1970.

Transylvania College opened in 1780 as the first college west of the Appalachians. The college is in an area that was part of Virginia when it opened but was transferred to Kentucky when it became a state in 1792. The college accepted women in 1889 (from www.transy.edu).

Washington and Lee (www.wlu.edu) was established in 1782 and accepted its first women students in 1942.

The College of Charleston (www.charleston.edu) was chartered in 1785 so that wealthy citizens of the Charleston area did not have to send their sons to Europe for a higher education. Its purpose was to "encourage and institute youth in the several branches of liberal education." "Youth" meant young men, and the first woman graduated from Charleston in 1901.

Washington College (www.washcoll.edu), in Maryland, was chartered in 1782 and accepted women students in 1892.

Bowdoin College (www.bowdoin.edu) opened in 1799 and did not admit women until 1970 (from www. Bowdoin.edu). Despite this delay of 171 years, Bowdoin advertises its support of educated women in the 1800s. They do this by pointing out that Harriett Beecher Stowe's husband was a member of the Bowdoin faculty, and Mrs. Stowe wrote *Uncle Tom's Cabin* in her husband's study at the college (Chapter 2).

Remarkably, one college opened as a coeducational school — sort of. Franklin College, founded by Benjamin Franklin, had an initial class of 78 men and 36 women when bilingual (English and German) classes began in 1787. Richea Gratz was the first Jewish female college student in the United States. The founders were apparently horrified, however, when they realized what they had done. The college threw out all of the women students before the end of the first year, and coeducation did not come again until 1969 after Franklin merged with Marshall College to become the present Franklin and Marshall. (All information from the Franklin and Marshall website, www.fandm. edu.)

The status of women in America actually declined in the newly independent country. Not only could women not get into colleges, but they lost their limited right to vote. Prior to the Revolution, the only people who could vote were property owners, and that included women property owners. After the revolution, however, the restriction that only property owners could vote was

dropped and the franchise generally extended to all white males. This removed women from the voting rolls, and by 1787 women had lost the right to vote in all states except New Jersey. Women doctors and lawyers who had trained in Europe could practice their professions in the colonies but were soon displaced in an independent America.

Paradoxically, women were soon put in charge of the morals of the new country even though they were still regarded as the source of sin. Men were so busy with their own affairs, that the proper raising of children was left to "republican mothers." These women were supposed to educate young children in "dame schools" in the women's homes. Naturally, they would teach the importance of the bible — bit of irony to leave this to women. And of course, women were supposed to remain sexually pure while the men did as they pleased.

## How the possibility of higher education for women started

French philosopher Jean Jacques Rousseau wrote that women should be educated to take care of us (i.e., men) when we are young, to please us throughout our lives, and to console us when necessary.

Rousseau clearly represented orthodox opposition to education of women, and it took unorthodox people to begin providing educational opportunities for women in colonial America. These people existed partly because Jan Hus was condemned for heresy and burned at the stake in Prague in 1415. Hus was a Catholic priest who did not believe all of the papal tenets and formed a group of worshippers called Hussites. Persecution drove the

group underground until the 17th century, when it was reconstituted in the Moravian area of central Europe and renamed Moravians.

Continued persecution gave a missionary zeal to surviving Moravians, and they began overseas operations in the late 1700s. They established missions and schools all the way from northern Labrador to North Carolina. These Moravians brought with them a firm belief in the equality of men and women (regarded as heresy by other religions), and that led to their interest in women's education.

This belief in equality of women and men meant that the only religious or secular group interested in the education of colonial women was the Moravians. The present Moravian College in Pennsylvania began in 1742 as essentially a high school known as the Bethlehem Female Seminary, the first school for young women in the colonies. It became the Moravian Seminary and College for Women in 1913 and merged with men's schools in 1954 to become coeducational Moravian College (www.moravian,edu). The Moravian community in Salem, North Carolina, established a girl's school in 1772. It is now Salem College for women (www.salem. edu).

## My opinion

Are you ready to criticize American society for not letting women go to college in the 1700s and early 1800s?

Hold on! Think about what life was like in colonial time.

The contrast between life in modern America and colonial America suggests one difficulty faced by women in colonial society. There was simply too much work to do to obtain the necessities of life to leave time for anything more than a rudimentary education. That raises the question of whether men could have taken over some of women's work and freed women to go to school. Put another way, did men spend so much time lounging around in taverns that women had to do all of the work?

Perhaps to a slight degree. Just as it is today, men undoubtedly spent more time in taverns than women did (and there were a lot of taverns in 18th-century America). But ordinary men also had a lot of work to do. They had to plow fields, clear land, cut lumber, build houses, and help defend the community. All of these were jobs that women didn't have the physical strength to perform.

A further problem was that men couldn't replace women in all of their jobs. Because women bear and nurse babies, they have always bonded more completely with their children than the fathers have. Consequently, it was logical for women to keep "hearth and home" in colonial time while men ranged outside to provide a living.

The result of these problems was that free time for education was available only in families that had servants to do some of women's work — "servants" included people who were paid, indentured, or in slavery. These families were also the only ones that could send young men to college. Should they have sent young women to college in addition to, or in place of, some of the men?

There were two reasons to send men to college instead of women. One was the religious idea that women were inferior to men. The other reason was purely economic. Men who were going to be wage earners would benefit from college education more than women who would stay at home to take care of domestic chores. Women could learn to read and write without going to college, and that was sufficient in most wealthy families. This economic decision was generally reached both by mothers and fathers, and men could not solely be blamed for it.

So, can we blame men for the lack of education for women in the 1700s and early 1800s? Not wholly. In addition to the Moravians, a few men believed that women should be educated. There was also the problem that educated men would contribute more to family wealth than educated women. And finally, people who fully believed the bible thought that women should not be educated.

With all of these imponderables, I think a male culpability index of 6 is reasonable for the 1700s and early 1800s.

# 2. Pioneers vs. misogynists

## (19th century)

Horrors!

There's a college that is going to admit girls! And as students, not just for the obvious purpose.

Preachers were thundering from their pulpits that the world was going to hell in a handbasket, but the founders of Oberlin College in Elyria, Ohio, remained firm. They wanted a school that would accept women along with men. Also black men and women.

My God! If this goes on, women and blacks may even want to vote some day.

Oberlin opened in 1835, and the first three women graduated in 1841. Two of them married faculty members at Oberlin, and the third married another man shortly after graduation. All three women essentially disappeared from public life, and Oberlin could not be accused of developing harridans who traveled around the country demanding more rights for women.

Whew! What a relief.

Admission of women to Oberlin was the most visible part of a trend to educate women in the early 1800s. Although women's colleges had already opened in the South (Chapter 4), Oberlin's prominence in the northern

U.S. made it an example for other colleges in the 1800s. Some men's colleges decided that it would be a good idea to admit women, some new colleges were coeducational from their inception, and some colleges were established solely for women. This process followed different paths in different parts of the country, and we discuss them in Chapters 3 to 7. This chapter simply describes the general difficulties of overcoming traditional prejudices against college education of women.

Two major developments in the 19th century helped send women to college. One was a reduction in the grip that the bible had on people's lives, and the other was technology that reduced the amount of work that women had to do at home. These developments were indirectly aided by the federal Morrill Act of 1862, which established land-grant colleges, and directly by various state laws. All of this help, however, ran into the continuing resistance by both men and women. They included men (misogynists) who were afraid of women and wanted them to stay at home like good little girls. Some women also had the idea that women should be "ladies" who could perform their mission in life with nothing more than a rudimentary education. Some men and women in the late 19th century believed that women should not partake in vigorous physical activity and mounted campaigns to promote their views.

We discuss these issues here, then describe pioneering efforts to improve the status of women, show the initial progress of women's education, and finish with my assignment of a male culpability index.

## The bible loses its clout

The belief that the bible is literally accurate ("Inerrant") was firmly held through the 1700s and into the early 1800s. People even believed that the earth was created in 4004 BC. This date had been calculated in the 1600s by Archbishop Ussher, the Anglican Prelate of Ireland. Ussher made his calculation by assuming the bible accurately recorded the ages of patriarchs when they "begat" their oldest sons (daughters didn't count!). Using these numbers led Ussher to calculate a period of 3418 years between the creation of Adam — forget Eve! — and the Babylonian capture of Jerusalem. Babylonian, Persian, and Greek records all date this capture at 586 B.C., and Ussher reached 4004 by adding 3418 to 586.

It was dangerous to believe that the bible wasn't inerrant. People weren't burned at the stake as Jan Hus had been 400 years earlier, but women caught in the Salem witch trials in the 1690s were hanged. A mixture of traditional piety and fear caused almost everyone to believe in biblical inerrancy, including the subservient position of women.

By the middle 1800s, however, people who actually read the bible (instead of being told what to think by preachers) realized that the creation stories in Genesis 1 and Genesis 2 contradicted each other. Historians and scientists challenged the date of 4004 BC for creation of the earth. Historians working in the Middle East discovered that Egyptian and other civilizations were older than the Hebrew civilization recorded in the bible. Geologists understood that the earth had to be much older than 4004 B.C. Biologists, particularly Charles

Darwin, showed that life "evolved" over a long period of time instead of being created at one time.

When these inaccuracies were demonstrated, people began to wonder if other parts of the bible should be taken literally. For example, are women responsible for sin and inferior to men? Should women really be subservient to men? Wouldn't it be a good idea to educate women as well as men?

## Technology to the rescue!

The amount of time that colonial women had to spend on domestic work was gradually reduced by technological developments in the 19th century.

One of the first time-saving inventions was the tin can. English inventor Peter Durand patented the tin can in 1810, and production began in 1813. Unfortunately, the first cans were soldered with lead, which led to neurological damage in people who used canned food too much

This danger was not recognized in the 1800s, and canned food became a great boon to women who had spent much of their time preparing food. Families on the frontier remained on a subsistence economy, but those in more settled areas raised money from their produce and could afford to spend it on "luxuries" such as canned food.

Another invention made it possible for women to spend less time lighting fires, candles, and lamps. Safety matches were invented by a Swedish chemist in 1844 and were mass produced in the 1850s.

Improvement of lighting throughout the 1800s and early 1900s made women's work easier. Instead of

making candles and pressing oil for lamps, women could buy whale oil by the early 1800s, and kerosene from drilled oil was produced by the middle 1800s.

Electric lights were developed in both Europe and America in the 1870s, and the Edison Electric Company began to electrify American cities in the 1880s. Electric lines spread slowly around America and did not begin to reach rural areas until the Rural Electrification Administration was established in 1935.

Widespread availability of electricity led to many labor-saving technologies. W.H. Hoover formed the Hoover Vacuum Cleaning Company in 1908 and sold vacuum cleaners worldwide — in some countries vacuuming is referred to as "hoovering." Paradoxically, vacuum cleaners did not make life easier for all women. Many colonial and early-1800 families cleaned their houses once a year — "spring cleaning." Some women who had used brooms and carpet sweepers to clean their houses a few times a year began to clean them every week when vacuum cleaners became available.

Improved refrigeration made life easier for women. People have known for hundreds of years that food could be preserved by storing it at sub-freezing temperatures. Some families could store food through the summer by cutting ice from lakes, packing it in large boxes or basements, and hoping it wouldn't melt before the next winter. This necessity came to an end in 1873 when German chemist Carl von LInde patented a machine that produced freezing temperatures by rapid expansion of gas (an "adiabatic" process). The ice produced by this process was then sold commercially, and many homes had "iceboxes" that contained large blocks of

ice delivered frequently by salesmen. It wasn't until the middle of the 1900s that all of these iceboxes were replaced by refrigerators that operated by von Linde's process. Food storage became even easier in 1922 when Clarence Birdseye invented "flash freezing" that allowed food to be stored frozen.

Pasteurization was developed by French chemist Louis Pasteur in 1862. Although fresh milk from a cow has to be used immediately before it spoils, boiling "pasteurizes" milk so that it can be kept in stores and sold commercially.

Public water supplies began to be developed in the 1800s in cities and large towns. The earliest systems brought water to buildings but did not provide sewer systems to take waste water away. This relieved women of the necessity of pumping and hauling water to their houses but left them with the problem of disposing waste. Even large cities still used outhouses and chamber pots in the early 1800s. The word "loo" comes from the French phrase "gardez l'eau (watch the water), which people called out when they threw the contents of chamber pots into the street.

The problem of waste disposal was mostly solved by the introduction of sewer systems that could use flush toilets. Ineffective varieties of indoor toilets had been invented about 1600 by the English writer John Harrington (from whom we have the term "john"). Better indoor flush toilets were later developed in the 1860s. Their exact inventor is unclear, but they are commonly attributed to English plumber Thomas Crapper, and these toilets were called "crappers." (For more information,

see *Flushed with Pride*, originally published in 1969 by Wallace Reyburn).

When water and sewer systems were in place, development of washing machines and dryers replaced the old methods of washing in a tub, passing clothes through a hand wringer, and hanging them on a line to dry. Production of these machines occurred from about the 1920s into the latter part of the 20th century. Although this apparently saved time for women, these machines caused people to want clean clothes every day instead of only occasionally.

The ability to buy, rather than to make, goods developed gradually during the 1800s. It was accelerated in 1882 when Aaron Montgomery Ward established a mail order business. His catalog — the "Wish Book" — soon reached everyone in the country who had postal service. Richard Sears and Alvah Roebuck formed Sears Roebuck in the 1890s and began to distribute their mail-order catalog in 1900.

## The Morrill land-grant act and state laws

Justin Morrill, a congressman from Vermont, persuaded Congress to pass the Morrill act in 1862. It established land grant colleges in all states and territories that were not in rebellion against the United States. The act provided grants of federal land to states:

*The leading object shall be, without excluding other scientific and classical studies, and including military tactics, to teach such branches of learning as are related to agriculture and the mechanic arts ... in order to promote the liberal and practical education of the industrial classes...*

The Morrill Act does not specifically mention women, but most land-grant colleges soon recognized that it would a good idea to develop programs in "domestic science" for women. These decisions converted many men's colleges to coeducational schools.

The constitution of the State of Arkansas was adopted in 1874 and includes the clauses

*"The equality of all persons before the law is recognized, and shall ever remain inviolate; nor shall any citizen ever be deprived of any right, privilege or immunity; nor exempted from any burden or duty, on account of race, color or previous condition."* and *"it is declared to be the purpose of this amendment to confer suffrage equally upon both men and women, without regard to sex; provided, that women shall not be compelled to serve on juries."*

These requirements made all schools established in Arkansas coeducational.

Wyoming became a state in 1890 and is known as the "equality state." This name comes from a territorial bill in 1869, when the 20 members of the Territorial Legislature voted that

*"Every woman of the age of twenty-one years, residing in this Territory, may at every election to be holden under the law thereof cast her vote."*

Women kept a vigil outside the Governor's office until he signed the bill, and the first woman cast her ballot in 1870. By 1871, two women were Justices of the Peace, and women were allowed to sit on juries. The result of this law was that all colleges established in Wyoming were coeducational. (Information about Wyoming and

other western states is from the website theautry.org/explore/exhibits/suffrage.)

The government of Ohio entered the fray in 1905. The state passed a law requiring coeducation in all public colleges and universities and colleges, including those receiving state or local financial support.

## Misogynists

"Man is made for the struggle of life. Woman for the repose of the warrior." (old Spanish proverb)

At least, the proverb doesn't insult women. Some of the "great thinkers" of the 19th century, however, dismissed women with contempt. A few examples will suffice.

Friederich Nietzsche was a German philosopher who believed that it was necessary to develop a "master race" that would rule the world, and he wrote "Man and Superman" to explain this idea. Nietzsche's work would ultimately underpin Hitler's claim that Aryans should be the master race.

Nietzsche clearly felt that the masters of the master race should be men. He thought that women must be strictly controlled by men.

Another 19th-century German philosopher was Arthur Schopenhauer. He thought so deeply that he decided he was a genius. (Well, of course!) He also recognized — naturally — that women were so inferior that they couldn't be geniuses.

Swedish playwright Johan August Strindberg referred to women as "half apes.".

Misogyny wasn't restricted to great thinkers. Many men felt that wives and daughters were their property and could be treated in any way the men wished. Under English Common Law, husbands could not be prosecuted for beating their wives. There was some restriction, of course. Beatings could only be administered with a stick no larger around than men's thumbs (the original "rule of thumb"). How merciful! Whips were OK because they were thinner than thumbs.

## The concept of lady

There is no better way to learn about 19th century ladies than to read Godey's Lady's Book. This monthly magazine, established by Louis Godey in 1830, was published by him until he died in 1878 and then continued until its final demise in 1898. It contained an amazing pile of drivel that reflected how Louis Godey thought ladies should live. Each issue contained a hand-colored steel-plate engraving of ladies dressed in the latest approved fashion. Many of these fashions included hooped underskirts that made dresses flare out so that sitting, and even walking, were difficult.

What the magazine did not contain was politics. Louis Godey even prohibited any mention of the Civil War, presumably because he didn't think ladies should be concerned that hundreds of thousands of American men were slaughtering each other. No, indeed! Ladies should only think of dresses and manners.

As an example of unreality, we can consider entries in the magazine during the summer of 1863. That was the summer when the Battle of Gettysburg was fought,

Vicksburg fell to Union forces, and Confederate raiders destroyed the town of Lawrence, Kansas (Chapter 5). Nothing of interest to ladies! Articles in Godey's discussed:

A morning at Stewart's — complaint that this New York store was no longer for ladies only

A new coiffure

A rustic hanging basket for window or porch

A sunset vision — poem

Decorations for the back and sides of slippers

Making a canvas carriage bag

A bead bracelet and chain

A new mode of painting in oil

Aunt Esther's warming pan

Cakes, puddings, etc.

Collar in waved lacet braid

Child's braided bib and band

OK, so women weren't supposed to be concerned about death and destruction, but in a surprising departure from frivolity, Godey's magazine occasionally had articles that were not about clothes and manners. Some of the most astonishing were articles in a series titled "Chemistry and Youth." Astonishing and very dangerous.

One experiment was to drop a piece of metallic potassium into a glass of water and light the hydrogen gas that bubbled out. Well, yes, the hydrogen would burn unless the whole thing blew up.

Another experiment proposed dropping calcium phosphide ("phosphuret of lime") into a glass of water and noting that the emitted gas (phosphine) burned

spontaneously in air. Indeed it would burn. Phosphine is used in incendiary bombs, and calcium phosphide is used in rat poison (it kills rats by reacting with liquid in their stomachs and generating phosphine.)

People who survived explosions and inhalation of poison gas could move on to other exciting experiments. One was to dissolve some phosphorous in ether, rub the liquid on their bodies and notice how they glowed in the dark. Godey's instructions didn't mention that nobody would notice the glow if they breathed too much ether and passed out.

What I did not find in Godey's was any mention of how many mothers and children were killed or permanently maimed and how many houses burned to the ground.

At least, Godey's did not specifically say that women should not be educated. That was left to other people. One of those people was Edward H. Clarke, M.D. and Professor of Medicine at Harvard. In 1875, after several colleges had admitted women students, Clarke published a book titled "Sex in Education: or A Fair Chance for Girls."

Fair chance? Fat chance! Clarke approached the education of women from a medical perspective. He described — in excruciating detail — women's reproductive systems, including not only pregnancy but also the problems posed by monthly menstruation. After treating several women patients and traveling widely in America and Europe, Clarke reached several conclusions:

Cultivating brains through education meant that other parts of the body would not develop properly. This was

not serious for boys, whose contribution to reproduction was very simple, but catastrophic for girls. Most of them would have a lifetime of illness, and many would never be able to have children.

Although girls might seem to do well academically in school, they should be withdrawn and brought home immediately at the first sign of trouble. Not just home, but possibly into a sanatorium. That is where Clarke sent some of his women patients.

If home and sanatoriums didn't make the girls feel better, there was always the possibility of sending the girls to Europe. During his travels, Clarke had observed that European girls who had just reached puberty were much healthier than their American counterparts. Presumably that was because European girls didn't waste their strength developing their minds, and they could concentrate on a life of being ladies and having babies.

Frenchmen Alexis de Tocqueville and Gustave de Beaumont visited America from 1830 to 1831. They both agreed that American girls had more freedom and responsibility than their European counterparts. Whereas European girls were chaste because they were innocent, American girls were chaste because of their knowledge. De Beaumont wrote "This coolness of the senses, the supremacy of the mind, this masculine behavior among women, may find favor with one's intellect; but they hardly satisfy the heart." (The quotation is from the University of Virginia American Studies website: xroads.virginia.edu/~HYPER/DETOC/fem/education.)

So, now we know what was wrong with young American women in the middle 1800s. They thought too much, didn't flirt enough, and weren't obedient. No wonder every effort had to be made to convert them into "ladies!"

## Should women be involved in vigorous physical activity?

Opportunities for women to engage in physical activity fluctuated throughout history. Physical labor was inescapable when most families lived subsistence lives on farms. As the 19th century progressed, however, people were able to buy more of the food and goods that they needed. This gave women who lived in relatively well-to-do families the opportunity to live without performing vigorous physical labor. This leisure clearly didn't apply to women on the frontier, but it did include many women in the eastern United States.

The possibility, perhaps not the desire, for a leisurely life led some men and women to lobby against physical exercise for all women. They were particularly determined that colleges with women students not allow the women to take any work in physical education. Both women students and college administrators wanted physical activity, however, but they organized it only by ignoring social pressure from outside the campus. Most colleges with women students arranged some type of activity that "hardened" the women's bodies.

Most women's colleges had field hockey teams and, after it was invented by James Naismith in 1891, basketball played by women's rules. Those rules

required teams of six players, each of whom stayed in only one half of the court. The three players on the "offensive" side of the court tried to score, and the three on the "defensive" side of the court tried to keep the other team from scoring. When a defensive player gained possession of the ball, she could pass it to an offensive player on the other side of the court but could not cross the center line herself.

Goucher College for women carried the strengthening process to an extreme. The college required that students read the bible, attend all classes, and participate in strenuous physical training. When the college opened dormitories, students had to sleep with their windows open in the winter in order to harden themselves more effectively.

Women students at coeducational colleges developed various strategies to obtain vigorous exercise. At the University of Minnesota, where men did military drills with rifles, women demanded the opportunity to drill with broom sticks. In Oklahoma, the website of East Central Oklahoma College (www.ecok.edu) reports

*"The State Department of Education had a requirement that all students participate in precision drill. The men drilled one hour and the women drilled half an hour. They would parade down Main Street, 600 girls behind the band."*

Why were some people opposed to physical activity? We don't know all of the reasons, but some are clear. Most of them center around the idea that women should save their bodies for bearing children. Another problem

was the type of clothing that women would wear if they exercised vigorously.

Strenuous activity was virtually impossible if women had to wear Victorian-style (ankle-length) dresses. Basketball could be played because women were restricted to half of the court. Field hockey and running, however, were practical only in clothing that allowed women's legs completely independent movement. This type of clothing was referred to as "bifurcated" and was similar to men's trousers.

The earliest bifurcated clothing in the United States was the "bloomer," which consisted of pants loosely gathered at the ankles and covered by a knee-length skirt. Bloomers were originally developed in the early 1800s, based loosely on the clothing worn by harem girls in the Middle East and Asia. They originally had various names, including "Syrian pants" because of their similarity to harem clothing.

This type of clothing was named "bloomer" because it was popularized in the 1850s by women's-rights activist Amelia Bloomer. Although they were derided by many men and women, bloomers immediately became popular for informal occasions. Formal wear was still restricted to wide skirts backed by hoops or made of crinoline, which was a stiff fabric made by a combination of horse hair and either cotton or linen. Hoops and crinoline made skirts so large that men who owned stores preferred men to bring their dogs instead of their wives because dogs would cause less damage than women wandering through the store.

Bloomers opened up a variety of activities for women. They could now play field hockey, run in track meets,

and ride bicycles. This freedom let colleges offer the type of physical education that most women demanded. Bloomers and other bifurcated clothing. however, were allowed only during physical activities, and women students were required to wear ankle-length (not hooped or crinoline) dresses to class and meals.

## Pioneers

A group of women met in Seneca Falls, New York, in 1848 to discuss ways to improve the status of women in America. They prepared a Declaration of Sentiments and Resolutions that is closely patterned after the U.S. Declaration of Independence. I show the crucial second paragraph of the Declaration of Independence below, with the additions at Seneca Falls in **bold type** and the deletions in small type.

"We hold these truths to be self-evident, that all men **and women** are created equal, that they are endowed by their Creator with certain unalienable Rights, that among these are Life, Liberty and the pursuit of Happiness. - That to secure these rights, Governments are instituted among Men, deriving their just powers from the consent of the governed, - That whenever any Form of Government becomes destructive of these ends, it is the Right of the People **to refuse allegiance to it**, alter or to abolish it, and to institute **insist upon the institution of** a new Government, laying its foundation on such principles and organizing its powers in such form, as to them shall seem most likely to effect their Safety and Happiness. Prudence, indeed, will dictate that Governments long established should not be changed for light and transient

causes; and accordingly all experience hath shewn that mankind are more disposed to suffer, while evils are sufferable than to right themselves by abolishing the forms to which they are accustomed.  But when a long train of abuses and usurpations, pursuing invariably the same Object evinces a design to reduce them under absolute Despotism, it is their right **duty**, to throw off such Government, and to provide new Guards for their future security.  Such has been the patient sufferance of these colonies **the women under this government, and such is now the necessity which constrains them to demand the equal station to which they are entitled. The history of mankind is a history of repeated injuries and usurpations on the part of man toward woman, having in direct object the establishment of an absolute tyranny over her**. To prove this, let facts be submitted to a candid world."

"The facts submitted include:
He has made her, morally, an irresponsible being, as she can commit many crimes with impunity, provided they be done in the presence of her husband.
In the covenant of marriage, she is compelled to promise obedience to her husband, he becoming, to all intents and purposes, her master— the law giving him power to deprive her of her liberty, and to administer chastisement.
He has denied her the facilities for obtaining a thorough education, all colleges being closed against her."

Two of the women involved in the Seneca Falls Declaration became famous for other activities.  One

was Elizabeth Cady Stanton. She was one of eleven children in the Cady family, All of the Cady boys died young, and after the last one died, her father said "Oh, my daughter, I wish you were a boy." When she married Henry B. Stanton, a strong abolitionist, Elizabeth agreed to the "love and honor" part of the wedding vow but refused to "obey."

Although raising five children, Cady Stanton continued to write and lecture. One of her major efforts was to prepare a "Woman's Bible" that removed or changed the more sexist parts of the conventional bible. She was not recognized as a biblical scholar, however, and "true scholars" — naturally all men — scoffed at her efforts.

Another leader of the Seneca Falls convention was Susan Brownell Anthony. She was the daughter of Quaker parents and followed many of their beliefs. She promoted temperance (a ban on alcohol) and women's suffrage. She was arrested when she attempted to vote in 1872 and later fined $100 after a sham trial. Naturally, she never paid the fine.

The stories of three other 19th-century women illustrate their situation. One of the first was Elizabeth Blackwell, who was accepted accidentally to the medical school at Geneva College, New York. As the only woman in the class, she was ridiculed by some, but not most, of the faculty and students. She told the few instructors who didn't want her in class that she would be glad to remove her bonnet and sit at the back of the room.

Blackwell received her degree in 1849 but was not allowed to practice medicine in American hospitals. So she went to France for further study but returned to New

York in 1857 to establish the New York Infirmary for Indigent Women and Children. Many of the nurses with the Union Army in the Civil War trained at the infirmary, and in 1868 Blackwell established a medical school to train women doctors.

A woman lawyer had problems similar to those of Elizabeth Blackwell. Myra Bradwell began her education during the Civil War and passed the Illinois bar examination in 1869. When the State of Illinois refused to let her practice law, she appealed to the U.S. Supreme Court. The Supreme Court initially denied her appeal because:

*"The natural and proper timidity and delicacy which belongs to the female sex evidently unfits it for many occupations of civil life. The paramount destiny and mission of women are to fulfill the noble and benign office of wife and mother. This is the law of the Creator."*

In 1892, however, the Supreme Court granted Bradwell a law license retroactive to the date of her application.

Ellen Henrietta Swallow began her education somewhat later than Blackwell and Bradwell. She graduated from Vassar College in 1870 and was then admitted to MIT as a "special student" — i.e., not a man — in chemistry. She continued at MIT for several years but was not awarded a Ph.D. because — well — she was not a man.

In 1875 Swallow married Robert H. Richards, head of the department of Mining Engineering at MIT. Then Swallow Richards worked on chemical analysis of ores and became the first woman member of the American Institute of Mining and Metallurgical Engineers. In

1876 she established the Woman's Laboratory at MIT and encouraged women to learn chemistry, biology, and mineralogy. She also founded the Association of Collegiate Alumnae (now American Association of University Women). Then she founded an oceanographic institute that is now Woods Hole.

By 1890, Swallow Richards was interested in nutrition. She coordinated efforts to train teachers for the new field of home economics. The American Home Economics Association elected her President in 1908. And, at last, she became Dr. Richards when Smith College awarded her an honorary Ph.D.

## First opportunities for college education of women

Women could not go to college until girls had a chance to receive an education approximating that of a modern high school. That opportunity was provided by the establishment — on a very limited scale — of female academies (female seminaries). We discuss these academies before moving on to colleges.

*Female academies*

One of the first female academies was in Litchfield, Connecticut. It was founded in 1792 by Sarah Pierce, who taught the only student in the dining room of her house. The school expanded and had several hundred graduates in 1833, when it closed upon the death of Sarah Pierce.

Litchfield and all other female academies faced the difference between what the teachers wanted to teach and what society wanted women to do. Most people — well, all men — wanted girls to prepare to be wives and

mothers. That meant that the girls should learn religion so that they would obey their husbands and teach their children to obey their fathers. Of course, singing, dancing, and the arts would teach girls to entertain their husbands when they weren't in bed. Throw in a little literature, and what else does a girl need?

The teachers at Litchfield and other female academies wanted to add more. Languages, a bit of math and science, some philosophy. Subjects that women would need to know if they weren't going to be completely subservient to their husbands throughout their lives. Some of the graduates became teachers, but they had to relinquish those positions as soon as they were married.

Litchfield's education reached more than 2000 students and led to at least one resounding success that everyone knows about. Catherine Beecher was the oldest of thirteen children and became responsible for the younger children when her mother died when Catherine was sixteen. She received some education at Litchfield, and after the children were old enough to be independent, Catherine formed the Hartford Female Academy in 1832. One of the first students was Catherine's younger sister Harriet Beecher. Harriet later married Calvin Stowe and, while raising seven children, published *Uncle Tom's Cabin* in 1850 under the name Harriet Beecher Stowe.

Many other female academies were established in the early 1800s. They include

Elizabeth Female Academy in Mississippi in 1818; it survived for 25 years and closed in 1843. Augusta Female Seminary in Virginia, was founded in 1842 and

is now Mary Baldwin College .A visitor to the Augusta Seminary in 1859 wrote

"I therefore feel no hesitation in speaking of the school as one, the great aim of which is, to impart a thorough, useful and sound education, while at the same time ample preparations are made for these branches deemed merely ornamental." (from the website of Mary Baldwin College; www.mbc.edu).

The Young Ladies' Seminary (now Mills College) was established near Oakland, California, in 1852, only two years after California became a state (Chapter 7). It allowed the newly prosperous families of California to educate their daughters without having to send them back to the east.

The Washington Female Academy in Georgia provides insight into the financial problems that many of these academies faced. The Academy taught "every branch of useful and ornamental education, with sedulous care in forming the manners and polishing and proportioning instruction to the abilities and temper of the pupil." Board and tuition, were $100, payable quarterly in advance; music, French, and drawing were extra. Washing cost an additional $11 a year. (From the website giddeon. com/wiilkes/history/soww4; a website about Wilkes County maintained by Keith Giddeon.)

## Colleges

Several private colleges accepted women in the 1830s. Georgia Female College (now Wesleyan College (www.wesleyancollege.edu) opened with 90 students in 1839 in Macon, Georgia. The curriculum included natural philosophy, mental and moral philosophy,

astronomy, botany, chemistry, physiology, geology, history, and ancient and modern languages. Because some of the women had transferred from the Clinton Female Institute, eleven of them graduated in 1840, one year before the first women at Oberlin. The first (in alphabetic order) was Catherine Brewer, who soon married Aaron Benson, had eight children and had no further effect on public life.

Hillsdale College, Michigan (www.hillsdale.edu), was established in 1844 with a charter that prohibited any discrimination based on race, religion, or sex. Oberlin and Hillsdale were followed by Antioch, founded in Yellow Springs, Ohio, in 1853 with three women students and — surprise, surprise! — a woman faculty member. Antioch's curriculum for both men and women students included Latin, Greek, mathematics, history, philosophy and science. The college also required "good moral standards" for graduation.

The Tennessee and Alabama Female Institute (later Mary Sharp College), was founded in Winchester, Tennessee, in 1851 with a motto of "Educate the mothers and you educate the people." Its curriculum included algebra, geometry, trigonometry, Latin and Greek, English literature, grammar, composition, American history, philosophy, rhetoric, geography, geology, botany, chemistry, astronomy, and physiology. It went broke and closed in 1896.

Elmira Female College (now Elmira College; www.elmira.edu) was established in 1855 in Elmira, New York. The college awarded the first degrees in 1858 and claims to be the first college to grant degrees to women

that were the equivalent of those given to men. Elmira College became coeducational in 1969.

Only two public universities accepted women before the Civil War. When the University of Iowa (www,uiowa. edu) opened in 1847, it was the first public university to accept men and women on an equal basis. Mormon pioneers arrived in Utah in 1847, and by 1850 they established Deseret College (now the University of Utah; www.utah.edu) for both men and women. There was no campus or faculty, and classes were held in private houses until the college had to close in 1853 because of lack of funds.

## My opinion

Women in the early 1800s clearly had more educational opportunities than they had in the 18th century. There were several reasons for this development. The amount of time that women had to spend on domestic duties was gradually reduced by technological developments. Fewer people thought that women were evil and did not deserve an education. More men realized that the entire society would benefit from the education of women.

Several factors were arrayed against these positive developments, however. Some men were still afraid of women. Some women preferred the sheltered life available to "ladies."

By the time of the 19th century, it still was not possible for little Susie to say to big Bob "Look, honey. Even you can open a few cans and fix dinner while I am in class." That would have to wait until the late 20th century.

Considering the progress in women's education made since the 1700s and the presence of both men

and women for and against this progress, I think a male culpability index of 5 is reasonable.

# 3. Twitter, Twitter in the East
## (northeastern U.S. in the late 1800s and early 1900s)

*Anonymous usually means women.* Dorothy Parker

The development of educational opportunities for women did not cause young women to become more interested in careers than in marriage and family life. Some graduates took jobs as teachers or clerical workers, but these positions were usually temporary until the women were married. Some employers fired women as soon as they were married.

The presumption that most women would be married and raise children affected the development of educational opportunities for women throughout the United States in the late 1800s. This development followed four different paths, all of which were pursued hesitantly. One was the establishment of colleges solely for women. A second path was the founding of "coordinate" colleges that would educate women near (but not with!) the men of existing men's colleges. The third effort was establishment of coeducational colleges, and the fourth was acceptance of women to established men's colleges. There is also a special category of colleges that couldn't decide what to do.

This chapter describes these efforts in the northeastern United States, and we discuss each of them before finishing with my opinion of the situation.

For the purpose of this discussion, we add Maryland and Delaware to the northeast, thus dividing states as they were divided by the Civil War instead of by

the Mason—Dixon line, which ran between Maryland and Pennsylvania.

## Women's colleges

| School | date founded |
|---|---|
| Mt. Holyoke, MA | 1837 |
| St. Mary's, MD | 1840 (admitted men in 1925) |
| Hood, MD | 1853 (admitted men in 2003) |
| Irving, PA | 1857 (closed in 1929) |
| Hood, MD | 1883(admitted men in 2003) |
| Vassar, MA | 1865 |
| Cedar Crest, PA | 1867 |
| Chatham, PA | 1869 |
| | (admitted men to graduate programs in 1994) |
| Wilson, PA | 1869 |
| Wellesley, MA | 1870 |
| Smith, MA | 1871 |
| Bryn Mawr, PA | 1885 |
| Goucher, MD | 1888 |
| Simmons, MA | 1899 |
| Notre Dame, MD | 1895 |
| New Rochelle, NY | 1904 |
| D'Youville, PA | 1908 (admitted men in 1970) |
| Emmanuel, MA | 1912 (admitted men in 2001) |

Hood College in Maryland (www.hood.edu) was founded in 1893 by removing women from a coeducational college in Pennsylvania; Hood became coeducational in 2003.

Colleges solely for women, and remaining women's colleges. were established for two reasons. One was frustration over the unwillingness of men's colleges to become coeducational. The other was the feeling — which still exists — that women will receive a better education in schools that do not include men (Chapter 11).

Although each college has a different history, they all shared several common characteristics. Many of the colleges were founded by religious organizations, and almost all required attendance at chapel. They all faced the problem of educating women who would live in a repressive, Victorian, society. This meant careful regulation of student behavior, including dress codes, supervision of — rare — meetings with young men, and of course, curfews. Most colleges were very small when they started — a handful of faculty and a few dozen women. Most of the colleges also had to face the problem that young women had not received significant preparation for college, and some colleges established "preparatory schools" that brought young women up to the level of first-year college students.

Another common feature in most, but not all, colleges was an emphasis on athletics. Society had generally frowned on any physical activity for women (except, of course, for having babies and milking cows). Most colleges, had field hockey teams and, after it was

invented by James Naismith in 1891, basketball played by women's rules (Chapter 2).

Some of the colleges began as female seminaries, which were unsuccessful and closed before 1900 or converted to four-year colleges. For example, Wheaton Female Seminary in Norton, Massachusetts, opened in 1835 with 50 students and three professors. The purpose of Wheaton was partly to train teachers but primarily to prepare the girls to be wives and mothers. By 1897 only 25 students were enrolled, and Wheaton closed the seminary and became the Wheaton College that exists today as a coeducational school (www.wheatoncollege. edu).

After Wheaton, Mount Holyoke Female Seminary, was established in 1837 and changed its name to Mount Holyoke College in 1893 (www.mtholyoke.edu). The Female Seminary was established by Mary Lyon, who had already flouted tradition by becoming a chemist. Her motto, and still the motto for the college, was "Go where no one else will go, do what no one else will do."

Lyon also challenged tradition by requiring entrance examinations for applicants and not including "home economics" in the curriculum. Tradition was upheld, however, by requiring attendance at chapel and strict curfews.

The next college for women in the northeastern U.S. was Irving Female College in Mechanicsburg, Pennsylvania. It was founded in 1857 and granted degrees until it closed in 1929.

Vassar (www.vassar.edu)( was established in 1865 under the leadership of Hannah Lyman (www. vassar.edu). Lyman — who never married — required

attendance at chapel, prevented students from wearing fancy dresses, enforced a curfew, and prohibited running. Essentially, any display of excitement or enthusiasm would be "unladylike." In the early years at Vassar, Lyman even censored all student letters to make sure they didn't contain any criticism of Vassar or any other statements that she considered improper.

Because Vassar was such a pioneer in women's education, it attracted scorn from both women and men. One wealthy woman said " The very fact that it is called a college for women is enough to condemn it. No refined Christian mother will ever send her daughter to Vassar College!" Many men thought that women lived in a "sphere" and that the college would take her out of it. No wonder Hannah Lyman censored letters from her students!

Cedar Crest College (www.cedarcrest,edu), was established in 1867 in Allentown, Pennsylvania, as the Allentown College of Women (www.cedarcrest.edu). Its founding was such big news that the New York Times published an article about it and the growing importance of women's education.

Wilson College (www.wilson.edu), in Chambersburg, Pennsylvania, was named for Sarah Wilson, an unmarried woman who endowed the college and supported women's education although she had never been to college herself (www.wilson.edu). Wilson was roughly patterned after Vassar and had a curriculum that included Greek, Latin, calculus, geometry, history, and science.

The school that is now Chatham University was founded as Pennsylvania Female College near

Pittsburgh in 1869 (www.chatham.edu) The intention was to provide an education for women "comparable to the education in the best men's colleges." The motto was, and still is, *"Filiae Nostrae Sicut Antarii Lapides"* (That our daughters may be as cornerstones polished after the similitude of a palace). A bit flowery, but it obtained money for a college!

Wellesley (www.wellesley.edu) initially consisted of one very large building that —somehow — contained all of the classrooms, living space for 314 students, and also living space for 14 faculty members (only one of them male). With students living in the same building as the faculty, it is obvious that students had to remain "well-behaved." The Wellesley motto of *Non Ministrari, sed Ministrare*, ("not to be ministered unto, but to minister") is still the motto today.

Smith College (www.smith.edu) was established through a bequest by Sophia Smith with advice from her minister (www.smith.edu). Her will stated:

*"I hereby make the following provisions for the establishment and maintenance of an Institution for the higher education of young women, with the design to furnish for my own sex means and facilities for education equal to those which are afforded now in our colleges to young men.*

*"It is my opinion that by the higher and more thorough Christian education of women, what are called their "wrongs" will be redressed, their wages adjusted, their weight of influence in reforming the evils of society will be greatly increased, as teachers, as writers, as mothers, as members of society, their power for good will be incalculably enlarged."*

Note the word "Christian" in the bequest. Smith was not founded to provide a liberal education as we view the term today, but to promote evangelical Christianity. That could only be done if all of the students behaved as "good girls."

Bryn Mawr was founded near Philadelphia in 1885 as a Quaker school but became non-denominational in 1893 (www.brynmawr.edu). The first Dean and second president was M. Carey Thomas, a woman who had gone to Europe to get a Ph.D. because no school in America would admit her. This rejection instilled a high level of irritation in Carey Thomas and led her to a lifelong desire to educate women at the same or higher level than men. It also led Bryn Mawr to offer both undergraduate and graduate degrees.

Goucher College was established in 1888 as the Woman's College of Baltimore City (www.goucher. edu). It had the lofty goal of offering courses in classics, modern languages, mathematics, science, music, and art, but the college had to deal with a large number of students who needed preparatory classes to get them ready for true college classes. Goucher also required that students read the bible, attend all classes, and participate in strenuous physical training. When the college opened dormitories, students had to sleep with their windows open in the winter in order to harden themselves more effectively.

The last women's college established in Massachusetts in the 19th century was Simmons College in Boston (www. simmons.edu). It was founded by Boston businessman John Simmons in 1899 to educate women in "useful

professions." These professions would, hopefully, enable women to live independently of men.

Notre Dame College of Maryland (www.ndm.edu) opened in 1895 with the motto Veritatem Prosequimur (We Pursue Truth).

New Rochelle College (www.nrc.edu) opened in Brooklyn in 1904 and originally consisted of one building that was the living, studying, and recreational center for all students.

## Coordinate Colleges

| School | date founded |
|---|---|
| Radclilffe, MA | 1879 (merged with Harvard in 1999) |
| Pembroke, RI | 1893 (merged with Brown in 1971) |
| Barnard, NY | 1889 (still coordinate with Columbia) |
| William Smith, NY | 1908 (still coordinate with Hobart) |
| Douglass, NJ | 1918 |

A lady suggested to Woodrow Wilson, then the President of Princeton University, that the school should accept women students "in order to remove the false glamour with which the sexes regard each other." Wilson is said to have answered: "Madam, that is the very thing we are trying at all costs to preserve."

That story may be a myth, but it introduces us to the concept of "coordinate" colleges. Instead of simply admitting women to men's schools, the schools

established women's colleges that would be "coordinate" with the men's colleges. The futility of this process is shown by the fact that all of the coordinate colleges have now merged classes and degrees with the men's schools, although some retain their original names.

Coordinate colleges were in the same towns as the men's colleges (most of them were just across the street), but most of the women's schools had their own faculties and courses.

The school that later became Radcliffe College opened as Harvard Annex in 1879 in a private house near Harvard (www.harvard.com). Classes were taught by Harvard faculty, and a bathroom in the house was converted to a physics laboratory — presumably for small classes! Because students lived in the house with the owners, the students had plenty of "mothering" whether they wanted it or not.

One of the early students at Harvard Annex was Helen Keller, who became both deaf and blind when she was 19 months old. When she was old enough to go to college, she considered Wellesley but decided on Harvard Annex because there were "only girls at Wellesley."

The birth pangs of the school that would become a coordinate college for Brown University began in 1874, when the first woman applied for admission to Brown. The leaders of Brown twitched at the idea of women students and twittered for 17 years until they finally decided to form a coordinate college in 1891 (www.brown.edu). Well, sort of form a coordinate college

Classes were originally held in a grammar school after the boys went home at two o'clock. Because the school

had no lights, the women worked until the daylight was too dim to read by. The original faculty were "loaned" by Brown until the college received its own faculty in 1903. Official recognition of the college as a body of the university came in 1896.

When the women were able to occupy their own building, the name of the school became a problem. Originally it was the "Women's College of Brown University," but that was considered to imply too close a connection with Brown, and that name was changed to "Women's College Adjunct to Brown University." After the name was changed to Pembroke College of Brown University in 1911, male students who still objected to the presence of women referred to it as "Deadbroke College." Brown and Pembroke merged into one school in 1971.

In 1889, Frederick A.P. Barnard, then the tenth president of Columbia College (now Columbia University) wanted to admit women to Columbia (www.columbia. edu). When the Columbia trustees vetoed that idea, Barnard established Barnard College for Women across the street from Columbia. Barnard is still independent but so closely coordinated with Columbia that Barnard students can major in Columbia programs.

Hobart College in New York was founded as Geneva College in 1842 and was an all-male school except for the almost accidental granting of a medical degree to Sarah Blackwell (Chapter 2). In the early 1900s, local nurseryman William Smith decided that women should also be educated. He gave enough money to establish William Smith College in 1908 as a coordinate college

to Hobart (www.hws.edu). That coordinate relationship remains to the present.

The New Jersey College for Women opened in 1918 under the direction of Mabel Smith Douglass, the founder and first Dean (www.douglass.edu). The one building that constituted the college had classrooms, offices, and chapel on the first floor, residence for Douglass and her two children on the second floor, and housing for sixteen students and their supervisor on the third floor. The New Jersey College for Women ultimately became Douglass College affiliated with Rutgers, the State University of New Jersey. Whether Douglass is independent, coordinated with, or just "related to" Rutgers is still being debated in the early 2000s.

## Coeducational colleges

| School | date founded |
| --- | --- |
| Alfred, NY | 1836 |
| St. Lawrence, NY | 1856 |
| McDaniel, MD | 1867 |
| Juniata, NY | 1876 |
| Curry, MA | 1879 |
| Drexel, NY | 1879 |
| Elizabethtown, PA | 1899 |
| Clarkson, NY | 1906 |

Coeducation in the northeastern U.S. developed slowly, haphazardly, and in some schools hypocritically. The record is difficult to interpret because some schools began as academies (essentially high schools), then became junior colleges, and converted to 4-year colleges

late in their histories. The dates given here are mostly the times at which the schools began to offer BA and BS degrees.

Coeducational schools developed in four ways. The predominant one was conversion of men's schools to coeducational later (much later!) than their founding, A few women's colleges converted to coeducation, although most women's schools remained as single-sex. A few colleges were originally coeducational, and some colleges couldn't decide what they wanted to do.

Several schools opened as coeducational and have remained so. Alfred University (www,alfred.edu) opened in 1836 and is now the "second oldest co-educational college in the United States and one of the earliest nineteenth century colleges to have enrolled African American and Native American students."

St, Lawrence College of New York has been coeducational since it was founded in 1856 (www.stlaw.edu). McDaniel College of Maryland, opened in 1867 with a total of 37 men and women students.

Juniata College (www.juniata.edu)opened in 1876 with a class of 2 women and one man. It has been coeducational until the present.

Curry College of Massachusetts was established in 1879 as the "School of Elocution and Expression." (www.curry.edu)

Drexel University opened as a coeducational school with the name Drexel Institute of Art, Science and Industry (www.drexel.edu).

# Colleges originally established for men

| School | date founded | date admitted women |
|---|---|---|
| Colby | 1813 | 1871 |
| Allegheny | 1815 | 1870 |
| Amherst | 1821 | 1975 |
| Trinity, CT | 1823 | 1969 |
| Lafayette | 1832 | 1970 |
| Holy Cross | 1832 | 1970 |
| Bucknell | 1846 | 1883 |
| Muhlenberg | 1848 | 1957 |
| Tufts | 1852 | 1892 |
| Penn. State | 1855 | 1871 |
| Elmira | 1855 | 1969 |
| St. Joseph, PA | 1859 | 1970 |
| Boston College | 1864 | 1970 |
| Cornell | 1865 | 1969 |
| Wash. & Jeff. | 1865 | 1969 |
| Manhattan | 1869 | 1971 |
| Canisius | 1870 | 1965 |
| Lehigh | 1870 | 1970 |
| Skidmore | 1903 | 1970 |

Pennsylvania State University (www,psu.edu) was chartered in 1855 as an agricultural school. Efforts to expand the curriculum to science and liberal arts were controversial, and enrolments were low when the first women (a class of six) were admitted in 1871.

Elmira College opened for men in 1855 and became coeducational in 1969. Despite that delay in admitting women, Elmira claims to be "the first college founded to

offer women degrees for a course of study of equal rigor of the best men's colleges of the nation." (www.elmira. edu)

St. Joseph College of Philadelphia (www.sju.edu) opened as a Jesuit school for men in 1859 and admitted women in 1970 after it had become more secular.

Boston College opened in 1864 as a men's school, allowed women to attend their "extension division" in the 1920s, and became fully coeducational in 1970 (www. bc.edu).

The table above shows that the time between the opening of a men's college and the admission of women was a minimum of several decades for all schools and more than a century for some.

## Colleges that couldn't decide what to do

Many schools knew that women existed but didn't know what to do about them.

Bucknell became a college in 1848 and founded a "Female Institute" in 1852 (www.bucknell.edu). Bucknell College courses, however, weren't available to women until 1883.

Clark University, in Massachusetts, opened in 1891, and by 1896 decided that "ladies will be admitted to special courses on the usual terms." The college became fully coeducational in 1940.

Colby-Sawyer (www.colby-sawyer.edu) opened as a coed school in 1838. It threw out all of the men in 1928 and then became coeducational again in 1989.

Adelphi College (www.adelphi.edu) took a similar path. It was established as a coed school in 1893, threw the men out in 1912, and became coed again in 1946.

Arcadia College (www.arcadia.edu) has a reverse history. It was founded as a women's college in 1853, threw the women out in 1872, and became coed in 1907.

Keuka College (www.keuka.edu) opened as a men's school in 1890, threw the men out in 1921 to become a women's school, and then became coed in 1965.

Rensselaer (RPI) opened in 1853 . The website www.rpi.edu) shows the following sequence of events: When RPI officially identified itself as "coeducational" in 1942, a typical attitude was reflected in this 1958 correspondence between Joan J. Brown, Class of 1947, and Edward Dion, Secretary of the Rensselaer Alumni Association. "Mrs. Brown inquired whether RPI was considered coeducational. When Brown asked General Secretary Richard Schmelzer for verification, the latter wrote "we are coeducational even though we don't stress the fact because we don't want too many gals around. "

There were never more than eight female students in one class at Rensselaer. This scarcity can be explained by several reasons: Rensselaer was not promoted as coeducational; "It was not equipped to respond to the needs of women students;" and "campus housing and student services were not designed specifically for coeds. The school, however. did have a "ladies course."

The first woman to formally apply for admission to Rensselaer was Elizabeth R. Buswell in 1873. According to an October 4, 1873 newspaper clipping in a scrapbook compiled by E. Ray Thompson, Director Charles Drown "encouraged Miss Buswell to drop her application. He informed her that "the Institute makes no discrimination in regard to sex, but ... Miss Buswell's position as the

only lady student would not be pleasant. If three or four other ladies were willing to join with her, it is probable they would be welcomed."

As recently as 1961, the Polytechnic (student newspaper of RPI) quoted one coed as saying, "Rather than being stared at and being regarded as freaks, we would like to be treated as humans." The article also says that the women were "tired of being interviewed."

By the early 1960s, changes in attitudes toward females on campus began to take place. In 1960, R.P.I. and Russell Sage College established a cooperative program to accommodate Rensselaer's women students. The women would reside at Sage. which had "appropriate facilities and support systems", and take classes at RPI. The arrangement was not convenient for the young women, but it at least acknowledged the growing need for change.

An article from the Polytechnic (December 16, 1964) discusses some of the problems that Rensselaer had to solve before it could be promoted as truly coeducational. The author discusses the social and academic difficulties faced by women students and how the school could help solve them. However, he also expresses a prevailing fear that "young women might waste an excellent education by rushing into marriage after college, and speculates that this could jeopardize the professional futures of other coeds.

By 1966 Rensselaer cautiously began to promote its coeducational status by building one wing of a dormitory for women students.

The website of Wesley College of Delaware (www.wesley.edu) reported that in 1880 "While association among the sexes is not encouraged, rather discouraged, but once a month there is held a public reception when all the students and their friends can meet in the parlor of the ladies' hall for an evening together."

The website of Ursinus College of Pennsylvania (www.ursinus.edu) describes how Ursinus became coeducational instead of for men only. Minerva Weinberger was a student at nearby Pennsylvania Female College, which closed in 1880. Minerva was the daughter of J. Shelly Weinberger, a professor at Ursinus. Since there was no other college for Minerva to attend, Ursinus admitted her, and she did so well that Ursinus became coeducational in the next year. Minerva Weinberger graduated valedictorian of her class in 1884. "

## My opinion

Women's education in the Northeast in the 1800s was a complex mess. Most of the difficulty seems to have been caused by men, although some women were clearly opposed to higher education. I think a male culpability index of 7 is reasonable.

# 4. Surprises in the South
## (1800s in the southern U.S.)

*"University girls are ladies and ladies do not root at football games."* After saying this, the matron of a women's residence at the University of Texas collected all of the horns and whistles from students who were leaving the residence to go to a football game. (from a reminiscence of Katherine Searcy, who graduated in 1905; www.utexas.edu))

The concept of "lady" held on longer in the South than in other parts of the United States. Women in the South were almost worshipped by men. Courtesy required a whole range of actions by men. Some were the simple tasks of opening doors so that women could precede them and also never using "strong language" that might offend women. Women could reorganize whatever was happening around them by simply "feeling faint," although this was sometimes referred to as "having the vapors." Sex was a dirty word, and women were somehow supposed to have babies without knowing anything about it.

I remember that women were considered to be delicate creatures even in the 1960s. Some mothers seemed to feel that their daughters at Rice were "petals from the precious flower of southern womanhood." The daughters, naturally, felt differently.

The Civil War had at least as much effect as the concept of "lady" on education in the South. Some colleges were destroyed in the Civil War and never reopened. Some were destroyed but managed to reopen after the war. Some Yankees, who regarded themselves more-or-less as missionaries, arrived in the South with enough money to establish new colleges after the war.

Despite the complexities caused by the Civil War, we discuss the development of women's education by following the same organization as in Chapter 3 on the Northeast: establishment of colleges for women; founding of coeducational and coordinate colleges; conversion of men's colleges to coeducational; and colleges that couldn't decide what to do. We find that, surprisingly, college education for women proceeded at least as rapidly in the South as in the northeastern United States. We finish with my opinion of the situation.

## Women's colleges

The first colleges solely for women in the South were established by private groups, mostly church-related. Southerners, however, went further than people in other parts of the country and established state-supported schools for women.

Some women's colleges were founded before the Civil War. They generally survived the war, whereas some men's colleges had to close and never reopened.

## *Before the Civil War*

| School | date founded |
|---|---|
| Athens, GA | 1822 |
| LaGrange, GA | 1832 |
| Wesleyan, GA | 1839 |
| Mary Baldwin | 1842 |
| Limestone, SC | 1845 |
| Hollins, VA | 1852 |
| Columbia, SC | 1854 |

Peace College and Queens College of North Carolina illustrate the problem of deciding exactly when a women's college opened. Both schools were founded in 1857, but Peace College remained a pre-college school and junior (2-year) college until after the Second World War. Queen's College is less specific about the level of education provided at different times in its history. Queens, however, refers to itself as an institute or academy for girls or young ladies until it finally uses the term "College for Women" in 1899.

Two contrasting viewpoints illustrate the differences of opinion about the education of women in the South. In a Phi Beta Kappa address at a southern school, one man said "The best diploma for a woman is a large family and a happy husband." Conversely, an article in the Southern Christian Advocate said that "both sons and daughters must be well educated because the yoke matrimonial sits heavily upon those between whom there exists a marked intellectual disparity." (Both quotes are from the website of Columbia College, which was established

in 1854 as a two-year college for women in Columbia, South Carolina; www.columbiacollegesc.edu).

Columbia College was established to "educate young women for fruitful service to church, state and nation." In pursuit of this education, students learned "math, science, grammar and composition, Latin, and religion/philosophy." The college charged extra for music, French, and art.

The Georgia Female College in Macon, Georgia, opened in 1839 and claims to be the world's oldest women's college. It is now Wesleyan College of Georgia (www.wesleyancollege.edu), and it retains its motto "First for Women."

Limestone College (www.limestone.edu) was established in 1845 as the first women's college in South Carolina. The founders were Thomas Curtis and his son William, both from England. William Curtis later was one of the men who signed the South Carolina Articles of Secession at the start of the Civil War. Limestone survived the war and became coeducational in 1960.

Hollins College (www.hollins.edu), in Roanoke, Virginia, evolved out of coeducational Valley Union Seminary, which had been established in 1842. By 1852 the school was restricted to women and named Hollins College. The man who spurred the early growth of Hollins College was Charles Lewis Cocke, a mathematics tutor from Richmond, Virginia. The Hollins website claims that, at the age of 19, Cocke wrote that he wished to "dedicate himself to the 'higher education of women in the South." He also wrote that "The plan and policy of this school recognizes the principle that in the present state of society in our country young women require

the same thorough and rigid training as that afforded to young men."

OK, so I accept the idea that Charles Cocke was a remarkable man. How about also describing him as "unusual?" Isn't it unusual for a nineteen-year-old man to be interested in women from an intellectual rather than a hormonal viewpoint?

## *After the Civil War (private schools)*

| School | date founded |
| --- | --- |
| Lander | 1872 |
| Shorter | 1873 |
| Winthrop | 1886 |
| Littleton | 1887 |
| Agnes Scott | 1889 |
| Converse | 1890 |
| Meredith | 1891 |
| Randolph-Macon | 1893 |
| Sweet Briar | 1906 |

Numerous colleges for both men and women opened after the Civil War ended. Most of them, both private and public, were for men. A few schools were coeducational from their beginning. Private women's colleges were founded for a variety of reasons. They include preparation of teachers, endowments from women, even the desire of the founding men to have a place where their daughters could go to school. We illustrate these reasons by describing two of the schools.

The home page of the Sweet Briar College website (www.sbc.edu) says "THINK IS FOR GIRLS." THINK is pink, and most of the rest of the page is also pink.

Sweet Briar College opened in 1906 with a gift from Indiana Fletcher Williams in memory of her only daughter, Daisy, who died at the age of 16. According to its founder the purpose of the college would be to prepare young women "to be useful members of society." (from www.sbc.edu)

Randolph-Macon Women's College would never have existed if the trustees of mostly male Randolph-Macon College were ready to admit women in 1891. The president of the college, however, wanted to extend the same educational opportunities to women that were available to men, and he found enough support to open Randolph-Macon Women's College in Lynchburg, Virginia (about 100 miles from Randolph-Macon College in Ashland). It was one of the few women's colleges in the South to offer 4-year B.A. degrees to women. The college changed its name to Randolph College when it became coeducational in 2007 (www.randolphcollege. edu.

## After the Civil War (public schools)

| School | date founded |
|---|---|
| Mississippi University for Women | 1884 |
| Georgia State College | 1889 |
| North Carolina University at Greensboro | 1891 |
| Texas Women's University | 1901 |
| Florida State | 1905 |
| Mary Washington University | 1908 |

78

The only state-supported colleges for women in the United States were established in the South. The reasons stated by the universities are the normal pieties on the importance of educating women. Behind them, however. is the suggestion that women would have to learn to support themselves in a region where so many men had been killed in the war that many women would remain unmarried for their entire lives.

The histories of several schools support this conclusion.

Mississippi University for Women was approved as the Industrial Institute and College by the Mississippi State Legislature in the early 1870s. It wasn't chartered until 1884, however, when the legislature approved money for its support and made it the first state-supported college for women in America. The purpose of the school was to provide "a high quality collegiate education for women coupled with practical vocational training." As one legislator said, "it was a "Godsend' for the "poor girls of Mississippi." Mississippi had the foresight to recognize that "her young women were going to have to be taught not only to think for themselves, but also to support themselves." (from the MUW website; www,muw.edu.) The school admitted men in 1962.

Julia Flisch, a journalist in Augusta, lobbied for the establishment of a publicly funded college for women that would "prepare them for the demands of the new industrial age." She was successful in 1889, when the Georgia Normal & Industrial College was chartered as a two-year college that would emphasize teacher training and business skills. The name of the school was changed

to Georgia State College for Women in 1922 (www.gsu. edu). Courses included psychology, home economics, English, math, art, science, recreation, and music. The school became coeducational in 1967.

The school that is now the University of North Carolina at Greensboro (www.uncg.edu) was chartered by the North Carolina Legislature in 1891. It opened in 1892 with 15 faculty members and 198 students. The school was founded after "strenuous promotion" by Dr. Charles Duncan McIver on behalf of the education of women. The original name as the State Normal and Industrial College shows that the main purpose was to train women to become teachers and to qualify for jobs as secretaries and clerks in industries. In 1932 the school was renamed as the Women's College of the University of North Carolina. The first men were admitted in 1964.

An act of the 27th Texas Legislature in 1901 founded the Girls Industrial College . The school would become Texas Woman's University in 1957. The school was intended to provide a liberal education and to prepare young women with a specialized education "for the practical industries of the age" (from the TWU website; (www.twu.edu). The university has been coed since 1972, although some students staged a long-running protest against coeducation.

Mary Washington University was founded in 1908 as the "Virginia State Normal and Industrial School for Women. It was later renamed for the mother of George Washington. In its early years, "all applicants were required to be at least 15-years-old, of good moral character, and possessing a thorough knowledge of subjects taught in grammar grades of the public schools.

Students were expected to practice self-control and required to wear "clothing of simplicity and modesty." (from the website www.umw.edu.)

The Florida State Legislature established two colleges in 1905. The school in Gainesville, now the University of Florida (www.ufl.edu), was reserved for men, and the school in Tallahassee was designated the Florida State College for Women. Because of local demand, a few men were admitted in Tallahassee. In 1947 the legislature gave up the idea of separate schools for men and women and changed both schools to coeducational. At the same time, the school in Tallahassee was renamed Florida State University (www.fsu.edu).

## Coordinate Colleges

Only one southern college can be regarded as truly coordinate. Sophie Newcomb College of Tulane University was founded by this gift from Josephine Louise Newcomb to the Trustees of Tulane University on Oct. 11, 1886:

*Gentlemen: In pursuance of a long cherished design to establish an appropriate and lasting memorial of my beloved Daughter, H. Sophie Newcomb, deceased...I hereby donate to your Board the sum of $100,000, to be used in establishing the H. Sophie Newcomb Memorial College, in the Tulane University of Louisiana, for the higher education of white girls and young women. ... I further request that the education given shall look to the practical side of life as well as to literary excellence..."*

(from www.tulane.edu.)

81

This gift came at a time when William Johnston, President of Tulane, wanted to educate women but was concerned that the people of New Orleans would think that the education of men would be reduced in quality if women were allowed on the campus. No problem. The first Sophie Newcomb building was built far enough away from the Tulane campus that the men and women would never have to see each other. Sophie Newcomb was also made acceptable to the people of New Orleans by an early concentration on music and art, with pottery particularly important. The separation was maintained until 1914, when the two campuses were moved next to each other, and some coeducational classes were taught.

Tulane and Newcomb remained as coordinate colleges until hurricane Katrina did so much damage to New Orleans in 2005 that both colleges closed temporarily. When they were ready to reopen, the Tulane administration (www.tulane.edu) decided to save money by becoming coeducational and closed Newcomb. This closure led to a lawsuit filed in 2006 by an heir (great-great-great niece) of Josephine Newcomb to keep Sophie Newcomb as a separate college. The legal complexities were still unresolved in 2010.

# Coeducational colleges

## Before the Civil War

| School | date founded |
|--------|--------------|
| Tusculum, TN | 1794 |
| Mississippi Coll. | 1830 |
| Guilford, NC | 1834 |
| Huntingdon, AL | 1854 |

Mississippi College, in Clinton, Mississippi, developed from an academy/high school into a private 4-year college in 1830. It was coeducational from the beginning, and in 1831 it granted the first B.A. degree in America to a woman (a fact promptly ignored by "intellectuals" in the Northeast; Chapter 3).

## After the Civil War.

| School | date founded |
|--------|--------------|
| Trinity, TX | 1869 |
| Texas Christian | 1873 |
| Vanderbilt, TN | 1875 |
| Univ. Texas | 1883 |
| Troy State, AL | 1887 |
| Reinhardt, GA | 1888 |
| Millsaps, MS | 1889 |
| Lenoir-Rhyne, NC | 1891 |
| Lincoln Mem., TN, | 1897 |

| | |
|---|---|
| Elon , NC | 1899 |
| Barton, NC | 1902 |
| William Carey, MS | 1906 |

Texas Christian University (TCU) grew out of AddRan male and female college, established as a "Christian school" in 1873 in Thorp Spring, Texas. The college was founded by Joseph Clark and his two sons Addison and Randolph after his sons returned from the Civil War. The college name comes from Addison's first-born son, who died in infancy.

The founders initially planned to open a college in Fort Worth, but they decided that the "big city" would corrupt the students, and they moved the school to the tiny village of Thorp Spring (where presumably nothing ever happened; Thorp Spring's largest population was in 1904, when it almost reached 500). Only 17 students appeared for the first day of class, but the enrolment rapidly grew to several hundred.

AddRan College changed its name to Texas Christian University and moved to Fort Worth in 1912. All information from www.tcu.edu.

Trinity University (www.trinity.edu) began classes in 1869 with both men and women students. Similar to Addran College, Trinity was isolated from the corrupting influence of a big city by its location in the tiny village of Tehuacana, six miles from the nearest railroad station. Trinity moved to San Antonio in 1942.

The University of Texas (www.utexas.edu) was founded in 1883 and already had problems with its "experiment in coeducation" in 1884. The school hired a woman to be Dean of Women and clear up the mess.

Barton College was initially founded as Atlantic Christian College in 1902. Although the first class included 20 men and 87 women, the college catalogue referred to the college as "a female boarding school." The women were required to wear uniforms because "It obviates the difficulty of invidious distinction in dress, saves expense, time, thought." Tuition and board, September to June, was $150. Education in music and art each required an extra $30. (all information from the website of Barton College; www.barton.edu.)

The initial faculty and staff of Atlantic Christian College included: one woman to teach Latin and mathematics: one woman to teach science, English, and history; one woman to teach elocution, art, and chapel management; one woman to help students prepare for college work; one woman to teach voice; two women to teach piano; a woman principal, a woman matron; and a man as attendant physician.

The people who established Vanderbilt University (www,vanderbilt.edu) in 1875 expected that it would be for male students. They never prohibited women, however, and there was at least one woman student every year from the beginning. Most of the women were special (non-degree) students until 1892, when women were allowed to enroll as regular students. The number of women was small, however, until Vanderbilt constructed a women's dormitory in 1901.

# Colleges originally established for men

## Before the Civil War

| School | date founded | date women were admitted |
|---|---|---|
| Univ. N. Carolina | 1793 | 1960s |
| Univ. Tennessee | 1794 | 1894 |
| Univ. Georgia | 1801 | 1919 |
| Centenary, LA | 1820 | 1895 |
| Spring Hill, AL | 1830 | 1932 |
| Randolph Macon, VA | 1825 | 1971 |
| Univ. Virginia | 1825 | 1920 |
| Univ. Alabama | 1831 | 1893 |
| Mercer, GA | 1833 | 1913 |
| Citadel, SC | 1833 | 1996 |
| Wake Forest, NC | 1834 | 1890 |
| Emory & Henry, VA | 1836 | 1931 |
| Davidson, NC | 1837 | 1969 |
| Emory, GA | 1838 | 1953 |
| Clemson, SC | 1843 | 1964 |
| Univ. Mississippi | 1848 | 1893 |
| Catawba, NC | 1848 | 1975 |
| Rhodes, TN | 1848 | 1960 |
| Austin, TX | 1850 | 1918 |
| Roanoke, VA | 1853 | 1930 |
| Brevard, NC | 1853 | 1934 |
| Sewanee, TN | 1857 | 1969 |

Randolph-Macon was established for men in 1825. Women were admitted as day (non-resident) students in the late 1890s. The Randolph-Macon website describes living conditions in the campus dormitories that show

why women would not have come as resident students even if they had been admitted. (from the website of Randolph Macon College; www.rmc.edu.)

Students lived in cottages that held 16 people in 8 bedrooms. All heating was by wood stoves, and students had to saw their own wood. There was no plumbing, and water was hauled from a well. Baths were in the gymnasium, and students arranged for meals, generally with nearby boarding houses.

In 1971 Randolph-Macon officially became coeducational with the enrollment of 50 women. At the same time, B. J. Seymour joined the faculty as the first full-time female faculty member. She was also the first woman to attain tenure, chair a department, and be granted the rank of full professor.

The University of Virginia (www,uva,edu) was established as a men's school in 1825. It remained placidly male until 1920, when women over 20 years of age were able to enroll in graduate programs. Finally, under threat of lawsuits, Virginia admitted women to all programs in 1970.

The University of Georgia ( www,uga.edu) was founded for men in 1801 and remained all male for the entire 19th century because trustees thought that the admission of women would "dilute" the education of men. The possibility of admitting women seems to have died in 1899 when the Georgia State Assembly established the Georgia Normal and Industrial College for women. By 1903, however, women could attend summer school, and in 1919, Mary Ethel Creswell became the first woman to receive a baccalaureate degree from the University

of Georgia.  The school later hired her to establish a program in home economics.

Birmingham-Southern College (ww.bsc.edu) is a coeducational school formed in 1916 by the merger of all-male Birmingham College with the women's Southern University.

Samford University (www,samford.edu) was founded as Howard College before the Civil War.  It was destroyed by the war and had to reopen later and move from  place to place.  The school was kept financially afloat by admitting small numbers of women students in the late 1800s and early 1900s, and it became officially coeducational in 1913.

Emory University was originally founded as Emory College in 1836 (www.emory.edu).  The school moved to Atlanta in 1915 after large donations of money and land by the founder of the Coca Cola company.  The first woman to attend Emory was the daughter of the president of the college.  She enrolled in 1883 but eventually transferred to another college to get her degree.  Gradually Emory began admitting women to special schools, such as nursing, but it wasn't until 1953 that Emory became fully coeducational.

The University of North Carolina at Chapel Hill (www. unc.edu) was founded in 1793 as a men's school.  That restriction broke down gradually.  By the late 1800s, the daughters of faculty members began attending classes.  Then the daughters of anyone who lived in Chapel Hill.  In 1916 the university built its first residence for women, thus allowing students from other parts of North Carolina to attend school.  Women could register as graduate students and as juniors and seniors after

finishing the first two college years elsewhere, such as the Women's College in Greensboro It wasn't until the 1960s that women could come to the school as freshmen and complete their degrees in four years. For more information, see "Ladies on the Hill" on the website www.unc.edu.

The first woman to receive a Bachelor's degree at the University of North Carolina was Sallie Walker Stockard. The website www.unc.edu summarizes her problems at the university. She was not allowed to march in graduation ceremonies and received her degree privately. She had never been allowed in the library but had to get a male student to go to the library to get her books. Someone published the following poem in the Daily Tar Heel (the student newspaper):

*She knew all the mental giants*
*And the master minds of science*
*All the learning that was turning*
*In the burning mind of man;*
*But she couldn't prepare a dinner*
*For a gaunt and hungry sinner*
*Or get up a decent supper*
*For her poor voracious papa*
*For she never was instructed*
*On the old domestic plan.*

Stockard continued for a masters degree at North Carolina and then went to Columbia for further graduate work.

Davidson College (www.davidson.edu) was founded in 1837, and no one at the school even considered admitting women until the late 1960s. Then the college approached the admission of women hesitantly (website chkierstead@davidson.edu). Many difficulties were considered. Urinals would have to be replaced in some bathrooms. The cafeteria would have to serve more choices of fruit and salad. More nurses would have to be hired for the clinic, and it was estimated that each woman would require 1.4 times as much medical help as a man. Polls showed that enrolled students were generally in favor of admitting women, but most alumni were opposed.

The first step at Davidson was to admit 30 women in 1969 on a transfer basis from a local women's college. Then women were admitted to the freshman class in 1971. At this time, some men began to complain of a reverse discrimination when they found that the college charged a laundry fee to all single men but waived it for women and married men.

## After the Civil War

| School | date founded | date admitted women |
|---|---|---|
| Louisiana State | 1869 | 1906 |
| Virginia Tech | 1872 | 1921 |
| Texas A&M | 1875 | 1963 |
| NC State Univ. | 1887 | 1921 |
| South, Carolina | 1891 | 1894 |

Virginia Tech (www.vt.edu) opened in 1872 as a men's school. *A Short History of Virginia Tech* by Duncan L. Kinnear describes the process of becoming coeducational. It started in 1918 when J.A. Burruss was appointed President of Virginia Tech. Burruss was an alumnus of Virginia Tech and had spent five years teaching at a female academy in Searcy, Arkansas. He thought that extension of suffrage to women had made them full citizens and it would be illegal to deny them admission to a school supported by both state and federal money. He also thought that housing would not be a problem because so few women would enroll that they could be housed in the President's house if necessary. The first women were able to enroll in 1921, and degrees in home economics were awarded in 1929. Full acceptance of the ability off women to do college work was acknowledged when Virginia Tech built a residence for women in 1940. "

## Colleges that couldn't decide what to do

Baylor University, Texas, was established in 1841 as a coeducational school. The school then abolished coeducation in 1846 and remained a men's school for 40 years. In 1886, however, Baylor decided to become coeducational again and recruited women so vigorously that one third of the entering freshmen were women.

Mississippi State University was founded in 1880 primarily as a military college for male "cadets" and was referred to as Mississippi A&M. A few non-resident women were admitted in the early 1900s, and that led to scandal in 1912. (Remember that what is considered normal behavior now was scandalous in 1912.)

According to the Mississippi State website (www.msstate.edu), the Vice President of the school found a cadet visiting one of the women students in the ladies study room of the library during the noon hour. (What the Vice President was doing in the ladies study room is not clear.)   Anyway, the military department issued an order saying that "cadets ... will not be allowed to visit the young ladies of the college in their study rooms at the noon hour, or periods when they are not in recitation. Neither will they be allowed to meet these young ladies in the chapel or other rooms for the purpose of social conversation or study." (from www.mssstate.edu)

Because the women did not  live on campus, this order virtually prohibited any social interaction between men and women students.  This order was fine with the women, but it incensed the men.  The senior cadets asked the president of the school to apologize to the women and organized a strike in which all undergraduate men stayed way from class.  Then the women recanted their original statement, saying they had signed it without realizing "its true nature."

Then the Governor of Mississippi got involved in talks with students and trustees.  Ultimately, all of the enrolled students were allowed to finish their work and get degrees, but the trustees took no chance of a repeat.  They decided that "Co-education at Mississippi A&M College is not desirable and that any girl student withdrawing now from the college be not permitted to re-enter and that in future the entrance of girls as students be discouraged."

One woman student was a junior at the time of the order and needed one more year to finish her degree.

The President of the college asked the governor to make an exception for her so that she could finish, but the Governor refused. So the college prohibited the woman from taking classes but did allow her to take examinations. When she graduated in 1914, she was the last woman to get a degree from Mississippi A&M until the Trustees reversed their ban on women in 1930.

Duke University North Carolina (www.duke.edu), was originally established as Trinity College in 1859. It was officially coeducational, but the only woman to receive a degree did so in 1878. When the school moved to Durham in 1892, it allowed women to enroll as full students.

The school that is now Furman University, South Carolina, (www.furman.edu) was established in 1826 as a men's college. The school enrolled women students from 1893 to 1900, when it abandoned coeducation and reverted to a men's college. In 1933, Furman coordinated with the Greenville Women's College, but the two campuses remained separate. Complete coeducation on the Furman campus was achieved in 1961.

## My opinion

Some men in the South were opposed to the education of women, but other men made that education possible.

Men opposed to the education of women did so for several reasons. Some thought that the presence of women on a campus would dilute the education of men. Some men held to the traditional belief that educating

women would be a waste of effort because they would spend their lives at home raising children.

Men in favor of the education of women had a broad variety of reasons. A few simply wanted a place where their daughters could go to college. Some seem to have been dedicated to the concept of women's education. The motives of men in state legislatures that established public women's colleges are unclear. Some legislatures founded women's colleges to reduce the pressure to integrate men's colleges. Conversely, some legislatures recognized that women would have to be educated in, order to support themselves in the post-Civil War South.

At least poor women would have to support themselves. But what about women who retained some wealth after the Civil War and, probably had husbands to support them.? They could be "ladies" and maintain their places in society without bothering about an education.

All of these ambiguities about men's and women's attitudes make it difficult to assign a male culpability index. I am, however, impressed by the concept of lady that permeated southern society even when I was teaching at southern universities in the late 1900s. Based on this experience, I am more inclined to blame women than men for the lack of educational opportunities for women in the South. I assign a male culpability index of 2 to the South in the 19th century.

# 5. Lost in the Woods
## (Appalachians to the Mississippi River)
## (1800s to early 1900s)

*"No student is allowed to communicate orally, by writing, or by signs, with students of the other sex."* (from an 1888 catalog of Hendrix University in Conway, Arkansas; www.hendrix.edu)

The area between the Appalachians and the Mississippi River was covered by forest when European colonists pushed westward into it in the 1800s. These forests also covered the Ouachita Mountains of Arkansas, and we include it in this chapter.

Colonists faced the enormous task of clearing the woods for farms and towns and building roads. They also realized the importance of education and established academies and colleges as soon as the population was large enough to spare a few young people for higher education.

The title of this chapter comes from the inconsistency with which colleges approached the admission of women students. We follow the same format as in the preceding two chapters: founding of women's colleges; establishment of coeducational colleges; and founding of men's colleges that later became coeducational. No coordinate colleges were established in this region We finish with my opinion of the situation.

## Women's colleges

| School | date founded |
|---|---|
| St. Mary's, IN | 1844 |
| Midway, KY | 1847 |
| Rockford, IL | 1849 |
| Mt. Mary, WI | 1850 |
| Defiance, OH | 1850 |
| Lake Erie, OH | 1859 |
| Ursuline, OH | 1871 |

The first women's college was St. Mary's College in Indiana. Students at St. Mary's in the 1960s left records of their lives at the school, and we discuss them in Chapter 9.

St. Mary's was followed in 1847 by Midway College of Kentucky, originally Kentucky Female Orphan School (from www.midway.edu) .

Rockford College was established in Illinois in 1849 and admitted men in 1965. The records of Rockford College (www.rockford.edu) show the following timeline to trace the difficulties of establishing the college:

In 1835, The town of Rockford was co-founded by Germanicus Kent and Thatcher Blake on the west shore of the Rock River.

In 1836, The first bridge was built across the Rock River.

In 1838, The first stagecoach arrived from Chicago.

In 1844, Rev. Aratus Kent, brother of Germanicus Kent, founded the Rockford Female Seminary and

became first President of the Board of Trustees both of Rockford Female Seminary and Beloit Men's College.

In 1849, The first seminary classes were held n a former county courthouse .

In 1852, A railroad linked Rockford and Chicago.

In 1877, Jane Addams started classes at Rockford Female Seminary.

In 1882, Jane Addams received one of the first four bachelor degrees.

In 1889 Jane Addams and Ellen Gates Starr founded Hull-House.

In 1931, Jane Addams received the Nobel Prize for Peace.

In 1955, Rockford College became coeducational.

Defiance College (www.defiance.edu), which now accepts men, was originally Defiance Female Seminary in 1850.

Lake Erie College (www.lec.edu) was founded for women in 1859 and admitted the first men (two brothers) in 1935.

Ursuline College (www.ursuline.edu) was established in 1871 and has remained a women's college to the present.

## Coeducational Colleges

| School | date founded |
| --- | --- |
| Oberlin, OH | 1835 |
| Hillsdale, MI | 1844 |
| Hanover, IN | 1844 |
| Baker, MI | 1858 |

| | |
|---|---|
| Baldwin Wallace, OH | 1845 |
| Earlham, IN | 1847 |
| Otterbein, OH | 1847 |
| Lawrence, WI | 1849 |
| Eastern Michigan | 1849 |
| Hiram, OH | 1850 |
| Urbana, OH | 1850 |
| Heidelberg, OH | 1850 |
| Antioch, OH | 1852 |
| Mt. Union, OH | 1858 |
| Wheaton, IL | 1860 |
| Ripon, WI | 1863 |
| Wooster, OH | 1870 |
| Butler, IN | 1865 |
| Wilmington, OH | 1871 |
| Ohio Northern | 1871 |
| Toledo, OH | 1872 |
| Lyon, AR | 1872 |
| Morehead St., MN | 1873 |
| Union, KY | 1879 |
| Lake Forest, IL | 1876 |
| Trine, IN | 1884 |
| Alma, MI | 1886 |
| Cumberland | 1887 |
| Oakland, MI | 1891 |
| Northland, MI | 1892 |

About half of the colleges and universities founded in the late 1800s were coeducational at their beginning.

Well, sort of coeducational. Many schools declared themselves to be coeducational but found ways to

discourage enrollment of women students. They included not building women's dormitories, telling students that they would have to study in a "male environment," and keeping the number of women students so low that the few women students would feel uncomfortable. Keeping those problems in mind, we use several colleges and universities to show the difficulties faced by women in coeducational schools.

Oberlin (www.oberlin.edu; Chapter 2) one of the first colleges to promote, coeducation, had a distinctly different view of the education of men and women. Their website reports:

" The men had to hold  debates as part of their training in rhetoric, and the women had to attend in order to provide an audience."

Just listening irritated Lucy Stone, who wanted to learn to lecture, and Antoinette Brown (Blackwell), who wanted to learn to preach. Both wished for practice in public speaking. They asked the head of the Speech Department, and he consented. ... "Tradition says that the debate was exceptionally brilliant. More persons than usual came in to listen, attracted by curiosity. But the Ladies' Board immediately got busy, St. Paul was invoked, and the college authorities forbade any repetition of the experiment."

Wabash College, Indiana, (www.wabash.edu) asked Hanover to become a women's college coordinate with Wabash men's college, but the Hanover leadership wasn't having any of that. Hanover remained coeducational and Wabash for men to the present.

Urbana College, (www.urbana.edu)was established in 1850 by John Chapman, better known as "Johnny Appleseed."

Antioch College, founded in Ohio in 1852, illustrates more of the problems faced by women students. In addition to the usual curfews and other social restrictions placed on them, women could not exercise or take classes in physical education.

The first student to challenge Antioch's regulations was Olympia Brown, who came to Antioch in 1885 and was later ordained as a Universalist minister. The following information and quote is from the website www.antiochana,antioch.edu/Olympia%20Brown.htm.

Olympia was a headstrong student. She did not argue when her first-year English professor told the men students that they would have to deliver orations in class from memory, but women students were poor speakers and they could bring their speeches written and read them. Apparently, this was like waving a red flag in front of a bull. So, when her time came to speak Olympia delivered a "rousing oration with her manuscript rolled up in her hand."

Olympia also scandalized the people of Antioch by wearing bloomers (Chapter 2).

Carthage College (www,carthage,edu) opened in Illinois in 1853 and moved to Wisconsin in 1862. The first class graduated in 1875 and included three women and one man.

When the school that is now Adrian College (www.adrian.edu) was initially established in Leoni, Michigan, college leaders soon realized that the nickname of Leoni

was "whiskey town," and they moved the college to Adrian in 1859 (www.adrian.edu).

Valparaiso College in Indiana opened in 1859 with 15 students and 5 faculty members, four of whom were women.

Wheaton College was established in Illinois in 1860 with the motto "for Christ and His Kingdom." It has always stressed "faith and learning," and the two courses required when it opened were bible and geology. The website www. www.wheaton.edu reports the following description of the founding of Wheaton College:

"Wheaton College was founded by social reformer Jonathan Blanchard. President Blanchard lobbied for the abolition of slavery, universal coeducation, and the "abolishment of caste-like conditions in the United States." In 1870, 51 students were enrolled at Wheaton: 29 women and 22 men.

When the family of the first president, arrived in Wheaton in April, 1960 "The town was unspeakably dreary. The cold damp of the spring rains, the low marshy grounds, the inferior huddle of houses, the single college building standing alone in the midst of its campus, the boarding house at the foot of the hill, cheaply constructed,. altogether was wearisome and dreary."

John Fee's first effort to establish Berea College (www.berea.edu) in Kentucky was in 1859. The Berea College website (www.berea.edu) reports that Berea's first teachers were recruited from Oberlin College, an anti-slavery stronghold in Ohio. Fee saw his "humble church-school as the beginning of a sister institution "which would be to Kentucky what Oberlin is to Ohio,

anti-slavery, anti-caste, anti-rum, anti-sin." A few months later, Fee wrote in a letter, "we eventually look to a college — giving an education to all colors, classes, cheap and thorough." Pro-slavery forces, however, drove the college away, and it could not begin again until 1869.

Wooster College (www.wooster.edu) reports that the first president issued this warning: ":Wooster had the same expectations of its women as it had of its men and that men and women would be taught in the same classes and pursue the same curriculum." The first Ph.D. granted by Wooster was given to a woman, Annie Irish, in 1882, and many of the early women graduates made careers for themselves "in foreign missions, doing abroad what they could not easily do in this country — founding colleges, administering hospitals, and managing printing houses."

Ripon College, Wisconsin, was established as a coeducational school. but all members of the first graduating class were women (www.ripon.edu).

Butler University was established in Indiana in 1865. In 1873, Butler's president presented a challenge to women students: "We are the first to say to woman, you claim to be equal with man, prove it by your works. We have accordingly abolished all distinction in the courses of study for the male and female student, requiring the same for each in order for graduation." (from the Butler website www.butler.edu).

Although the University of Wisconsin was originally established as a men's school, it admitted women in 1863, and all satellite campuses of the state system

established in the late 1800s were coeducational from the start (www.uwisc.edu).

Although the constitution of the State of Arkansas effectively required that colleges be coeducational, early schools found inventive ways to skirt this stricture. The allegedly coeducational University of Arkansas was founded in 1871 but did not build a women's residence until 1905. Similarly, Hendrix opened in 1881 but did not build a women's residence until 1913. Hendrix also warned women that they would have to study in a dominantly "male environment."

## Colleges originally established for men

| School | date founded | date admitted women |
|--------|--------------|---------------------|
| Ohio Univ. | 1804 | 1963 |
| Spalding, KY | 1812 | 1968 |
| Cincinnati, OH | 1819 | 1906 |
| Kenyon, OH | 1824 | 1969 |
| Univ. Indiana | 1828 | 1867 |
| McKendree, IL | 1828 | 1865 |
| Illinois College | 1829 | 1903 |
| Denison, OH | 1831 | 1900 |
| Xavier, OH | 1831 | 1969 |
| Kalamazoo, MI | 1833 | 1848 |
| Franklin, IN | 1834 | 1847 |
| Knox, IL | 1836 | 1857 |
| DePauw, IN | 1837 | 1867 |
| Albion, MI | 1838 | 1857 |
| Ohio Wesleyan | 1842 | 1963 |
| Marygrove,MI | 1845 | 1971 |

| | | |
|---|---|---|
| Beloit, WI | 1847 | 1895 |
| Univ. Wisconsin | 1849 | 1863 |
| Illinois Wesleyan | 1850 | 1955 |
| MacMurray, IL | 1850 | 1871 |
| St. Norbert, WI | 1852 | 1952 |
| Mich. State | 1857 | 1870 |
| Quincy, IL | 1860 | 1932 |
| Augustana, IL | 1860 | 1881 |
| Hope, MI | 1862 | 1882 |
| Concordia, MN | 1864 | 1938 |
| Purdue, IN | 1865 | 1871 |
| Univ. Kentucky | 1865 | 1885 |
| Kent. Wesleyan | 1866 | 1990 |
| Univ. Illinois | 1866 | 1871 |
| Akron, OH | 1870 | 1881 |
| Elmhurst, IL | 1871 | 1930 |
| Georgetown, KY | 1877 | 1889 |
| Findlay, OH | 1886 | 1959 |
| Aquinas, MI | 1886 | 1923 |
| John Carroll,OH | 1886 | 1968 |
| Ashland, OH | 1888 | 1901 |
| Miami, OH | 1889 | 1905 |
| St. Francis, IL | 1890 | 1939 |
| St. Joseph, IN | 1891 | 1968 |
| DePaul, IL | 1898 | 1911 |
| Central, IA | 1901 | 1962 |
| Millikin, IL | 1901 | 1907 |
| Marquette, WI | 1905 | 1912 |

Conversion of men's schools to coeducational ones generated many stories that we now regard as hilarious. We discuss several of them here .

The University of Michigan officially became coeducational in 1870, but in 1866 Alice Boise sneaked into her father's class in Greek. She wrote later "I waited, with emotions never to be forgotten, for the roar of the advancing tread of my dreaded classmates. Would they howl and hiss? The door opened. They entered. Save for a little murmur they were silent. Some of them had been my classmates in the High School." (from the reminiscens of Alice Boise Wood as reported on the University of Michigan website; www.michigan.edu). Alice Boise didn't graduate, but her experience opened Michigan to coeducation .

Purdue University was established in 1865 as a men's school but decided to admit women in 1871, This decision spurred some hateful comments, one of which is this letter published in the Purdue newspaper in 1875 (www.purdue.edu):

"The Trustees of Purdue University have ordered, that after the present year, the school shall be open to both sexes. We regard this as an almost fatal mistake. We believe that as long as men and women are human beings or more properly male and female, each sex has a separate function in the economy of the race.

It is not necessary to prove this fact. It is necessarily admitted by every well informed and unbiased mind. This being true, it follows that any course of study suited to the highest development of one sex can not at the same time be the best for the other. If Purdue is to have

courses of study that will call forth the highest energies of the masculine mind, and fit that mind for the highest functions in life, it can not at the same time adopt those courses to the most vital wants of the feminine intellect.

It will not do to justify this action on the plea of justice. No one denies the right of women to education, nor to public education. That is not the point at issue. Purdue is designed to furnish technical education; to make farmers, miners, engineers, naturalists and chemists. This is its sole object. It is not intended that a general education is to be given within its walls, but that instruction be given to fit men for the highest proficiency in the most exclusively masculine professions.

To open these courses to females would be ludicrous were it not burdened with such ill omens for the future. "

In 1876, Ohio State University needed more students in order to justify the size of its faculty (www.osu.edu). Their solution was to admit all high school graduates, including women. Perhaps they were spurred by the necessity of placating women after formation of the Woman's Christian Temperance Union in Ohio in 1874.

The University of Illinois opened as a men's school in 1866. The Illinois website (www.llinois.edu) describes the delayed development of educational opportunities for women until 1871, when the university said they would "provide greater convenience of women."

In the fall of 1872, Illinois opened the School of Domestic Science. A flyer for the University from that year advertises it as follows:

"The University will offer, henceforth, unusual advantages for the education of young women. They

will have, as formerly, access to all of the Classes in Sciences, Arts and Languages. Besides this, provision is making [sic] for special instruction in Domestic Sciences, in Telegraphy, Phonography, Drawing and Designing, etc., and in Music."

"It is the aim of the School to give to earnest and capable young women an education, not lacking in refinement, but which shall fit them for their great duties and trusts, making them the equals of their educated husbands and associates, and enabling them to bring the aids of science and culture to the all important labors and vocations of womanhood."

A new Ladies Boarding House was constructed to keep them separate from the male students in the main building. The building was to provide "a pleasant home for young ladies and to secure them cheap board, which, under the care of an intelligent Matron and Instructress, the pupils will keep house and be instructed in Domestic Science. "

In addition to regular classes at Illinois, women had to attend gym classes and "the University assured parents that great pains will be taken to secure, to the utmost possible extent, physical vigor, robust health, and a graceful carriage, and to prepare young women to take enlightened care of their own health and of the health of others under their care."

Hope College (www.hope.edu) admitted women in 1882, and by the end of the century, the college decided that it would be necessary to build a women's dormitory "of thirty or forty rooms, together with music rooms, parlors and a refectory, all under the control of a lady

superintendent "who would be a worthy example of Christian culture and refinement for the girls."

Marquette was established as a Catholic men's school headed by a Jesuit priest.  In 1909, Father McCabe allowed nuns and laywomen to enroll as students.  His superior in Milwaukee did not approve of the admission of women, and Father McCabe appealed the decision directly to the Jesuit head office.  Women kept coming to Marquette as the head office considered the request. Approval of coeducation finally arrived in 1912, just as the first women were graduating.

## My opinion

My opinion of the educational opportunities for women in the region between the Appalachians and the Mississippi River is based on three observations. One is the standard recognition that men founded some women's colleges, some coeducational colleges, and some colleges that were later converted to coeducation. A second observation is that some colleges were coeducational in name only, with schools actively discouraging enrollment of women students.

The most important observation, however, is that I could find little evidence that women in the region were opposed to the education of women.  This contrasts sharply with attitudes of women in the Northeast and South (Chapters 3 and 4).  For this reason I assign a male culpability index of 8 in the region between the Appalachians and the Mississippi River.

# 6. No Problem on the Prairie
## (late 19th century between the Mississippi River and the Rocky Mountains.)

*The bicycle has done more for the emancipation of women than anything else in the world.* Susan B. Anthony

The great prairie in the middle of the United States extends from near the Mississippi River westward to the foothills of the Rocky Mountains. The boundaries of the prairie do not conform neatly to the boundaries of individual states. Arkansas, for example, is west of the Mississippi River but is so heavily wooded that it is included in Chapter 5. Similarly, the eastern part of Texas is discussed in Chapter 4, but West Texas is included in this Chapter. I have arbitrarily included all of Montana, Wyoming, and Colorado in this Chapter even though the transition between prairie and mountain lies approximately in the middle of these states. Also, I have included all of New Mexico in Chapter 7.

Settlers moved westward across the prairie during the late 19th century. As people occupied an area, they formed a "territorial government" with the intention of later being admitted as a state that would be a member of the United States. The table below shows the dates at which the present states became territories, were admitted to the U.S. as states, and established the first

public universities. Six states (Kansas, Minnesota, North Dakota, Oklahoma, South Dakota, and Wyoming) established public universities while they were still territories before becoming states.

## Dates established

| State | Territory | State | University |
|-------|-----------|-------|------------|
| Colorado | 1861 | 1876 | 1876 |
| Iowa | 1838 | 1847 | 1855 |
| Kansas | 1849 | 1858 | 1851 |
| Minnesota | 1848 | 1858 | 1851 |
| Missouri | 1820 | 1841 | |
| Montana | 1864 | 1889 | 1893 |
| Nebraska | 1854 | 1867 | 1869 |
| North Dakota | 1861 | 1889 | 1883 |
| Oklahoma | 1907 | 1890 | |
| South Dakota | 1861 | 1889 | 1862 |
| Wyoming | 1868 | 1890 | 1886 |

Notes:
Missouri was admitted as a state shortly after it was Incorporated in the Louisiana Purchase of 1803.
North and South Dakota were originally included in The Dakota Territory.
Oklahoma was originally Indian Territory.

We follow the same outline as in previous chapters. We discuss the establishment of women's colleges first, the schools initially planned as coeducational, and then men's colleges that were later converted to

coeducational. No coordinate colleges were established in the region covered by this chapter. We finish with my opinion.

In each section, the names and dates of founding the colleges are listed first. They are followed by discussions based on several of the college websites.

## Women's colleges

| School | date founded |
|---|---|
| Columbia College, MO, | 1851 |
| Maryville, MO | 1872 |
| Stephens, MO | 1833 |
| William Woods, MO, | 1898 |
| St. Catherine 4-yr college in MN, | 1911 |

St. Catherine University (formerly the College of St. Catherine) was founded in St. Paul in 1905 by the Sisters of St. Joseph of Carondelet, under the leadership of Mother Seraphine Ireland. The University is named for St. Catherine of Alexandria, the fourth-century Egyptian lay philosopher (www,stkate,edu). The college opened in January 1905, offering classes to high school boarding students and lower-division college students. Upper-division college courses were first offered in the academic year of 1911—12.

The website of Columbia College (www.ccis.edu reports that on January 18, 1851, Christian Female College (now Columbia college) received its charter from the Missouri Legislature, making it "the first women's college west of the Mississippi River to be chartered by a state legislature." The city of Columbia

strongly supported female education partly because the University of Missouri did not yet admit women.

"Back in 1851, a typical day for the [Columbia] students started at 6 a.m. The ladies took a morning walk then gathered for chapel. They attended classes until late afternoon then wrote a daily composition. After they studied and did chores, the students attended a Bible lecture every evening. They studied arithmetic, ancient history, grammar, ancient geography, philosophy, five books of Moses, and composition."

Stephens College (www.stephens.edu) reports that Dr. Werrett Wallace Charters was appointed director of research at Stephens and asked to build "the strongest curriculum found in any women's college in the world." Early studies were in social problems, philosophy of living, communications, physical health, mental health, and humanities.

## Coeducational colleges

| School | date founded |
|---|---|
| Clarke, IA | 1843 |
| Univ. Iowa, | 1847 |
| Cornell, IA. | 1853 |
| Culver-Stockton, MO, | 1853 |
| Hamline, MN, | 1854 |
| College of the Ozarks, MO, | 1856 |
| Simpson, IA, | 1860 |
| Bethany, KS, | 1861 |
| Univ. South Dakota | 1862 |
| Gustavus Adolphus, MN | 1862 |
| Univ. North Dakota | 1863 |

| | |
|---|---|
| Univ. Kansas, | 1863 |
| Emporia State KS, | 1863 |
| Macalester, MN, | 1864 |
| Ottawa, KS | ,1865 |
| Washburn. NE, | 1865 |
| Truman, MO, | 1867 |
| Southeast Missouri, | 1867 |
| Peru, NE, | 1867 |
| Drake, IA, | 1872 |
| Drury, MO | 1873 |
| Colorado State, | 1870 |
| St. Olaf,, MN, | 1874 |
| Colorado College, | 1874 |
| Park, MO, | 1875 |
| Univ. Colorado, | 1876 |
| Hastings, NE | 1882 |
| Kansas Wesleyan, | 1886 |
| McPherson, KS | 1887 |
| Univ. Wyoming | 1887 |
| Nebraska Wesleyan, | 1887 |
| Moorhead, MN, | 1888 |
| Missouri Valley, | 1889 |
| North Dakota State | 1891 |
| Texas Lutheran, | 1891 |
| Texas San Angelo | 1889 |
| St. Cloud, MN | ,1889 |
| Tarleton, TX | 1899 |
| Northern Colorado, | 1889 |
| Carleton,MN | 1890 |
| York, NE | 1890 |
| Concordia, MN | 1891 |
| Wayne State, NE, | 1891 |

| | |
|---|---|
| Graceland, IA | 1895 |
| Univ. Montana | 1895 |
| Montana School of Mines | 1895 |
| Wichita State, KS, | 1895 |
| Grand View, IA | 1896 |
| Morningside, IA | 1896 |
| Western Colorado, | 1901 |
| Pittsburg State, KS, | 1903 |
| Southwestern, TX, | 1910 |

The website of Culver Stockton (www.culver.edu) reports that the school was granted a charter by the State of Missouri to establish a "Christian University." Classes began in 1855, making the school the first coeducational college west of the Mississippi River. During the Civil War, classes were suspended while federal troops occupied the college's only building, Old Main. The college reopened in 1865.

Robert Stockton and Mary Culver, both of St. Louis.,made generous donations for residence halls, a new gymnasium, and grants for faculty salaries. Because of this gift, the college trustees voted to change the name of the college from Christian University to Culver-Stockton College in 1917 (from www.culver.edu)

During the late 1800s, dancing was forbidden between the sexes, though men and women were allowed to dance with members of their own sex. (from the website of the University of North Dakota; www.und.edu)

The Drury website (www.drury.edu) reports "Drury's gift of $25,000 was the largest, and the college was renamed for his recently deceased son." The early curriculum emphasized educational, religious and

musical studies. Students came to the new college from a wide area, including the Indian Territories of Oklahoma. The first graduating class included four women

The website of Missouri Valley (www.mova.edu) reports "That after the Chair of Biblical instruction in our college is open, the regular course of study for both males and females preparatory to graduation shall include the biography, history, geography, literature, and moral code of the Bible, to which may be added such elective studies therein as the faculty may prescribe." It was also decided by that the institution should be co-educational by the following resolution: "That the faculty and trustees of our college, in organizing the school, while arranging for such separate courses for male and female students respectively as their judgment shall suggest, shall, however, admit female students to any and all the classes of the institution as may be desired by them and award to them the regular honors of such classes upon the same basis as that established for males."

Southeast Missouri University (www.semo.edu) opened in 1867 as the North Missouri Normal School and Commercial College. On December 29, 1870 Missouri's General Assembly made the private college the First District Normal School, the first Missouri-supported institution of higher education established for the primary purpose of preparing teachers for public schools. In 1899, Southeast's fifth president, Willard Vandiver, coined the phrase "show me,"

The website of Cornell College of Iowa (www.cornellcollege.edu) shows that Cornell was founded as the Iowa Conference Seminary. It was renamed in 1857

after William Wesley Cornell, :a prosperous merchant and devout Methodist whose distant cousin, Ezra Cornell, founded Cornell University a decade later"." Cornell was the first college west of the Mississippi to grant women the same rights and privileges as men, and in 1858 was the first Iowa college to graduate a woman.  In 1870, the college resolved: "that color and race shall not be considered as a basis of qualification in the admission of students."  Cornell college  began offering education courses in 1872.

Drake University  www.drake.edu) opened in Des Moines in 1881 with 60 men and 17 women.  It offered "a well-rounded education that included emphasis on sciences and law alongside traditional studies in faith and literature."  It was named for Francis Marion Drake, who drove cattle from Iowa to California, rode steam ships to Panama and was a general for the Union in the Civil War.  He also became a railroad magnate and Governor of Iowa.

Grand View College of Iowa (www.grandview.edu) was founded in 1896 by Danish immigrants.  "There is often a core of Grand View students whose family ties date back to the early days of the College, some for as many as four generations.  In 2004 Grand View enrolled its first fifth-generation student, the great-great-great niece of one of the founding faculty."

The website of Carleton College  (www.caleton.edu) shows that William Carleton, of Massachusetts, gave $50,000 to the college, and it was named for him.  In 1882 the faculty banned "mixed" literary societies.

Concordia College (www.concordia.edu) opened on Oct. 31, 1891, only 10 years after the first Norwegian

settlers arrived in the Red River Valley. Concordia opened with 12 students, three instructors, and courses in English literature, natural sciences, mathematics, and piano; courses that were added soon included religion, business, Norwegian, voice, geography, and history. Twenty-one students graduated in June 7, 1893.

The website of Hamline College (www.hamline.edu) says that Hamline is Minnesota's first university and among the first coeducational institutions in the nation.

Peru State College of Nebraska (www.peru.edu) was founded as Nebraska's first college and was the third teacher education institution established west of the Missouri River.

The website of Gustavus Adolphus (www.gustavus,edu) discusses a problem with women's athletics. "Ruth Youngdahl Nelson '24 was the first woman inducted into the Gustavus Athletics Hall of Fame." A national anti-women's competition movement (Chapter 2), prompted Ruth to become a leader in the organizing of a local chapter of the National Women's Athletic Assn., and she was its first president."

The only teaching aids when Emporia State College (www.emporia.edu) opened were a bible and a dictionary.

The University of Kansas (www.ku.edu) was sited at Lawrence after a grisly episode in the town's history

The story starts when the area was "bleeding Kansas" during the Civil War. Kansas, at that time, was part of the Nebraska territory. Being adjacent to Missouri, where slavery was legal, parts of Kansas were occupied by people sympathetic to the Confederacy, although the Nebraska territory as a whole was pro-Union. This mix

of people led to raids by Confederates against Union towns.

One of the worst raids was by several hundred men led by the Confederate officer William Quantrill . it took place on the night of August 20, 1963, and resulted in the deaths of more than 100 men and boys plus the looting and burning of much of the town of Lawrence, Kansas.

Despite the social divisions, there was general agreement that Kansas should have a public university. This idea had first been brought up in 1856, and the main question was where to put the school. Lawrence wanted the university, but the town was so impoverished after the Quantrill raid that it seemed unlikely to be chosen.

Then a few months after the Quantrill raid, Boston textile magnate Amos A. Lawrence, made the town an outright $10,000 gift, which brought the University of Kansas to Lawrence.

The website of Kansas State University (www.k-state. edu) reports that Kansas State Agricultural College opened with 52 students; 26 men and 26 women. In 1867 the first graduating class consisted of 5 students: 2 men and 3 women. In 1898 the Domestic Science building was completed, the first building in the U.S. built for the sole purpose of teaching home economics. Programs were designed to offer Bachelor's degrees in agriculture, engineering, household economics and general studies.

Colorado State University (www.csu.edu) was established in 1870 as the Agricultural College of Colorado. The first students arrived in 1879, when the faculty consisted of the president and two other professors. The number of students  grew from 44

in 1892 to 112 in 1896, partly because the college developed a "Ladies Course."

Women at Colorado State who had notable achievements include:

Eliza Pickrell Routt, was appointed, to the State Board of Agriculture in 1895, Routt became chairwoman of a new committee on domestic economy. She promoted the college's new domestic-economy program, which offered courses such as the chemistry of cooking, home hygiene, and household economics. A Friday lecture was given on "anything that will aid in the development of a perfect womanhood."

Theodosia Ammons was appointed by Routt as, the college's first domestic-economy instructor, and by 1902 she was the college's Dean of Women's Work.

Inga Allison, a former science student at the University of Chicago, worked on high-altitude recipes, which have to be designed around the low boiling temperature .of water. A cooking lab was completed on campus in 1927, and one cooking experiment was conducted at an 11,800-foot elevation near Pikes Peak.

A fight about women's social regulations at Colorado State erupted in 1964 when Vicki Hays, who was 21 years old, moved out of campus dormitories because her 11: 00 pm curfew conflicted with her position as managing editor of the campus newspaper. When the school insisted that she obey the rules, she transferred to the University of Colorado,

## Colleges originally established for men

| School | date founded | date admitted women |
|---|---|---|
| Loras, IA | 1839 | 1971 |
| Grinnell, IA | 1846 | 1870 |
| Luther, IA | 1849 | 1932 |
| Westminster, MO | 1851 | 1979 |
| Coe, IA | 1851 | 1882 |
| Univ. Minnesota | 1851 | 1858 |
| St. Mary's (TX) | 1852 | 1963 |
| Iowa Wesleyan | 1852 | 1862 |
| Benedictine, KS | 1868 | 1971 |
| Augsburg (MN) | 1872 | 1926 |
| Colorado Sch. Mines | 1873 | 1894 |
| William Jewel, MO | 1873 | 1920 |
| Southwestern, TX | 1885 | 1920 |

The website of the University of Minnesota (www. umn.edu) reports that the first organized program at the University related to physical activity began in 1862 as compulsory military training for all men in the freshmen class. "While many men complained about the military training obligation, some women clamored for the privilege of doing so." In 1886, Company Q was organized for women to participate in military drills.

The Colorado School of Mines website (www.mines. edu) reports that the first formal commencement for two graduates was held in 1883, the first international student graduated in 1889, and the first female student graduated in 1898.

Col. William Travis of the volunteer Texas army wrote to the New York Christian Advocate to request a

Methodist missionary at a time when American settlers were thinking of rebelling against Mexico. The missionary arrived and helped start Southwestern University (www.southwestern.edu).

Southwestern is proud pf several accomplishments: beating UT-Austin in the first college baseball game played in the state; having three of the first five Rhodes Scholars in Texas; publishing the *Southwestern Magazine*, the first student literary journal in the state; having folklorist and author J. Frank Dobie graduate in 1910.

## My opinion

I find that men placed almost no impediment to the education of women in the Plains states. In fact, much of the progress in women's education resulted from the efforts of men. Therefore I assign a male culpability index of 2 to the situation discussed in this chapter.

# 7. Puzzled in the West

## (1800s in the western U.S.)

*History repeats itself, but it costs more the second time around.* Mark Twain

Many of the western states were still being settled when colleges and universities were opening in the rest of America. Thus, fewer colleges and universities were founded in the west in the 1800s than in other areas. All of the states covered by this chapter are west of the Rocky Mountains except for New Mexico, which is arbitrarily included here.

We follow the same sequence as in previous chapters, discussing women's colleges first, then coeducational schools and schools established originally for men. We finish with my opinion.

## Women's colleges

| School | date founded |
|---|---|
| Mills College, CA, | 1852 |
| Notre Dame de Namur, CA | 1868 |
| Marylhurst, OR | 1893 |

Mills College (www.mills.edu) was founded in 1852 as the Young Ladies' Seminary in Benicia, California,

two years after  California was admitted to statehood and the same year the city of Oakland was established. The University of California and Stanford had not been founded, and rich families wanted to educate their daughters without sending them to East Coast schools.

The Young Ladies' Seminary was established under the direction of Oberlin graduate Mary Atkins.  Cyrus and Susan Mills bought the Seminary in 1865 for $5,000 and renamed it Mills College

Mills was recently named one of America's "100 Coolest" green schools by *Sierra,* the magazine of the Sierra Club.

Notre Dame de Namur (www.ndnu.edu) was the first college in California to grant bachelor's degrees to women.

The Sisters of the Holy Names of Jesus and Mary founded Marylhurst  (which (means "Mary's Woods") in 1893 as the first liberal arts college for Northwest women. (www.marylhurst.edu)

## Coeducational colleges

| School | date founded |
| --- | --- |
| Willamette, OR, | 1842 |
| Pacific Univ., WA | 1849 |
| Pacific Lutheran, OR, | 1849 |
| Linfield, OR | 1858 |
| Whitman, WA, | 1859 |
| Chapman, CA | 1861 |
| Lewis and Clark, WA | 1867 |
| Oregon State, | 1868 |
| Albany, OR | 1873 |

| | |
|---|---|
| Brigham Young, UT | 1875 |
| Univ. Oregon, | 1876 |
| Univ. Washington | 1876 |
| Whitworth, WA | 1883 |
| Arizona State Univ. | 1885 |
| Univ. Utah | 1886 |
| Pomona, CA, | 1887 |
| Occidental, CA | 1887 |
| Whittier, CA | 1887 |
| George Fox, OR | 1890 |
| New Mexico State Univ. | 1890 |
| Washington State University | 1890 |
| Univ. Arizona | 1891 |
| Univ. Washington | 1891 |
| La Verne, CA | 1891 |
| Walla Walla, WA | 1892 |
| Univ, Nevada at Reno | 1896 |
| Humphreys, CA | 1896 |
| San Diego State Univ., CA | 1897 |
| Idaho State Univ. | 1901 |
| Point Loma Nazarene, CA | 1902 |
| Concordia, OR | 1905 |
| Heritage, CA | 1907 |
| Reed, OR | 1908 |

Willamette University (www.willamette.edu) was founded in 1842  It educated many of the Northwest's first leaders, artists and business people, established the first law school (1883) and the first school of medicine (1866) in the Pacific Northwest,Willamette was also one of the earliest coeducational institutions in the United

States, and its first graduate was a woman. Women were attending the School of Medicine as early as 1877.

Oregon's Pacific University (www.pacificu.edu) is the oldest chartered university in the West. The Oregon Territorial Legislature granted its original charter as the Tualatin Academy on Sept. 26, 1849. The charter predates statehood by 10 years, and was the first formal act of the territorial government.

Pacific University was conceived by a Congregationalist minister and a former teacher from Massachusetts who cared for and educated orphans of the Oregon Trail. The university issued the first baccalaureate degree in the region in 1863 to Harvey W. Scott, later the editor of the newspaper *The Oregonian.* Pacific's Old College Hall, built in 1850, housed the original academy, and is the oldest educational building in the West.

Linfield (www.linfield.edu) is one of the oldest colleges in the Pacific Northwest. It was originally founded in 1858. After a series of name changes, it became Linfield College in 1922 in memory of a Baptist minister.

In 1836, near the current city of Walla Walla Marcus and Narcissa Whitman established a Christian mission and a school to teach the Cayuse Indians to read and write in their native language. Later, the Whitmans provided assistance to Oregon Trail travelers. After the Whitmans were killed by Indians in 1847, a seminary established in their honor was founded in 1859. It became a four-year, degree-granting college in 1859 (www,whitman.edu). In 1913, Whitman became the "first college or university in the nation to require undergraduate students to complete comprehensive examinations in their major fields."

George Fox iwww.georgefox.edu) is the oldest Christian university in Oregon. It is named for the founder of the Society of Friends (Quaker) movement. It was established as the Friends Pacific Academy in 1885, which focused on Christian instruction. One of the first students was Herbert Hoover, a future President of the United States.

The Methodist Episcopal Church of Vacaville, California, bought Corvallis College at a sheriff's auction in 1859 and established Oregon State University (www. osu.edu).

The first president of the school was instructed to "upgrade both facilities and academics to the level of a real college." That upgrade meant an emphasis on Latin, Greek, and philosophy.

The first president of Oregon State was a firm believer in rules. The first college catalog prohibited "bad language and behavior, idleness, drinking and drunkenness, gambling, cards, billiards and so on." Women students had to be strictly supervised at all times. Athletics were prohibited. The president hired a woman educated at the very strict St. Mary's Academy in Portland in an effort to help enforce the rules. She quit after one year. The resignation of the first president led to even stricter rules, including "all communications between ladies and gentlemen on the college premises is strictly forbidden."

The Oregon State Alumni Association comments on two notable women.

Alice Biddle (Moreland) (1870), first woman graduate of Oregon State, completed her degree in just over three years with perfect grades and perfect attendance. She

graduated at age 16 and was known as "Corvallis' most intelligent young woman."

In 1889, Margaret Comstock Snell established the first Department of Domestic Science and Hygiene in the Western U.S. It was later named the School of Home Economics. Snell was often referred by her friends as the "Apostle of Fresh Air" because of her penchant for keeping windows wide open regardless of weather. She became a medical doctor before moving to Corvallis, but she decided that the "higher and nobler function of medical lore was to teach people how to keep well rather than to cure disease."

Albany College www.albany.edu) started as Lewis & Clark's College. It was funded by the Presbytery of Oregon and the town of Albany. It educated women and men equally within a common curriculum that focused on the classics and traditional courses.

Brigham Young University (www.byu.edu) opened in 1875. Brigham Young, president of the Church of Jesus Christ of Latter Day Saints (Mormons) said "I want you to remember that you ought not to teach even the alphabet or the multiplication tables without the Spirit of God."

The 1883, catalog of Whitworth College (www. whitworth.edu) stated "It is intended to give both sexes a thorough course of education equal to that of our best Eastern colleges, guarding well the moral and religious life of the students, ever directing them in pursuit of that learning and culture of mind and heart that make the finished scholar." Although it was under the control of the Presbyterian church, it was open to "all lovers of truth and learning."

The first woman to graduate from Arizona State University (www.asu.edu) was Mary Walker, who was born in Glasgow, Scotland, and moved to Arizona when her father became a horticulturalist at the university. After graduation, she taught in a one-room school house.

Washington State University (www.wsu.edu) opened in 1890. The first two presidents were forced from office in two years. The school began instruction in Home Economics in 1905 and in Education in 1907.

Whittier (www.whittier.edu) was founded by the Religious Society of Friends in 1887 as the Whittier Academy. Whittier College grew from the academy and was chartered by the State of California in 1901 with a student body of 25.

Both the town and the College were named in honor of John Greenleaf Whittier, prominent Quaker, poet, and leader in the abolitionist movement. The website says "Although no longer affiliated with the Society of Friends, the College remains proud of its Quaker heritage and deeply committed to its enduring values, such as respect for the individual, fostering community and service, social justice, freedom of conscience, and respect for human differences. In its more than 100 year history, Whittier College has embraced and upheld these values as the foundation for its academic and social community."

Occidental (www.oxy.edu) was established by Presbyterians in 1887. In 1888 the school opened with 27 men and 13 women students. On June 21, 1893, Occidental awarded its first degrees to Maud E. Bell and Martha J. Thompson.

Pomona College (www.pomona.edu) was incorporated on October 14, 1887, by a group of

Congregationalists who "wanted to recreate on the West Coast a college of the New England type, one that would represent the very best of what they had experienced as students in the finest colleges of the Eastern and Midwestern United States. "Pomona was coeducational at the start and "reflecting the 19th-century commitment of its Congregationalist founders to equity," was open to students of all races. Pomona's first African American student graduated in 1904, and then went to Harvard Law School."

New Mexico State University (www.nmsu.edu) began in 1889 as an agricultural college and experiment station near Las Cruces. The institution, was designated as the land-grant college for New Mexico under the Morrill Act and was named the New Mexico College of Agriculture and Mechanic Arts.

After merger with Las Cruces College. New Mexico State opened on January 21, 1890. In the first semester there were 35 students in the college level and preparatory classes and six faculty members. Classes met in the old two-room building of Las Cruces College until suitable buildings could be put on the 220-acre campus three miles south of Las Cruces.

When San Diego State University (www.sdsu.edu) opened in 1897 as a Normal school, it had 7 faculty and 91 students who were learning to be teachers in elementary schools. Classes were originally held in temporary quarters over a downtown drugstore. The curriculum was limited at first to English, history, and mathematics.

At the University of La Verne (www.ulv.edu) 75% Of the students were in teacher education in the 1920s and 1930s.

Idaho State University (www,isu.edu) opened in 1902 as a coeducational school (theoretically!). It had a men's dormitory when it opened but didn't build a women's dormitory until 1906.

Walla Walla University was founded as Walla Walla College in 1892, by the Seventh-day Adventist Church. It had 9 faculty and 80 students. One purpose was to give students "a Christian education, surrounded with influences favorable to the development of Christian character."

The University of Nevada at Reno (www.unr.edu) was founded in 1874 as the State University of Nevada in Elko, Nev., about 300 miles northeast of Reno. Unfortunately, almost nobody lived in that part of Nevada, and nearly half of the state's residents lived in the Reno-Carson City area. In 1885, the legislature moved the University from Elko to Reno.

The first building in Reno was Morrill Hall, named after Justin S. Morrill of Vermont, author of the 1862 Land-Grant College Act (Chapter 2) that led to the development of the University of Nevada. Morrill Hall housed the president's and registrar's offices, classrooms, library, museum, and living quarters for the groundskeeper. Men's and women's dormitories were both ready by 1896.

Point Loma University (www.pointloma.edu) started from six women who called themselves the "Bible College Prayer Circle." They wanted a bible school, but

the first president, Dr. Phineas Bresee wanted a more extensive education with a biblical basis.

A bible that belonged to Bresee is encased in protective glass to show his philosophy of "pursuing a well-rounded education and serving the poor out of a fierce and intense love for God and His Word. "

## Colleges originally established for men

| School | date founded | date admitted women |
|---|---|---|
| Santa Clara, CA | 1851 | 1961 |
| St. Mary's, CA, | 1863 | 1971 |
| Univ. California at Berkeley, | 1878 | 1879 |
| Seattle University, WA | 1891 | 1922 |
| Gonzaga, WA | 1881 | 1950 |

Santa Clara University (www.scu.edu) was founded in 1851 by the Society of Jesus as "Santa Clara College," on the site of Mission Santa Clara de Asís. It is California's oldest operating institution of higher learning. The "college" was originally operated as a preparatory school and did not offer courses of collegiate rank until 1853. By 1875, the size of the student body was 275, and one-third of the students were enrolled in the collegiate division.

Santa Clara grew during its first 60 years and was designated "The University of Santa Clara" in 1912, when the schools of engineering and law were added.

For 110 years, Santa Clara was an all-male school. In 1961, women were accepted as undergraduates, and

Santa Clara became the first coeducational Catholic university in California.

When St, Mary's College (www.stmarys-ca.edu) was a men's school. it required boarders to bring "at least three suits of clothing, handkerchiefs, towels, and table napkins," all of which would be washed by employees of the school. The students were "vigilantly" supervised.

"In the first year of coeducation, Saint Mary's had only about 40 freshman women, who "censored themselves in class discussions" to avoid being accused of raising issues that related solely to women.

The University of California at Berkeley (www.berkeley.edu) opened in 1869 during debate over the future of the new university. Should it provide a "classical" education or concentrate on agriculture and other "practical" subjects? The issue was resolved in favor of a classical program, based on core courses in Latin, Greek, history, English, mathematics, natural history, and modern languages.

The first graduating class at Berkeley consisted of 12 men. They were known as the "Twelve Apostles" because of their distinctive accomplishments in later life. They included a U.S. Congressman and California governor, a mayor, a bank president, two University of California regents, a businessman, an attorney, an engineer, a mathematics professor, a clergyman, and a rancher.

Although Berkeley was originally a men's school, women were admitted only one year after it opened. That's right — just one year!

Seattle University (www.seattleu.edu) opened in 1891 as a Jesuit Catholic university and the largest

independent university in the Pacific Northwest. In 1921, "night classes," admitted women students, then a scandal in Jesuit circles. Subsequent efforts to shut down the program reached all the way to the Vatican, but Seattle University became the first coeducational Jesuit college in the United States.

Gonzaga College (www.gonzaga.edu) started in 1881 when Gonzaga's founder paid $936 in "hard silver dollars" for 320 acres of land and water that people then referred to as "the old piece of gravel near the falls." In 1887 the College officially opened for "young Scholastics, whose ambition it is to become priests." It was exclusively for boys and was led by Jesuit priests. Enrollment for the 1887-88 academic year was 18 boys and young men.

Gonzaga was founded partially to build a college that would compete with Protestants for access to various tribes through Congressionally allocated and subsidized mission schools. The college began its first academic year September 17, 1887 with a Mass of the Holy Spirit, a tradition that continues today. Its Jesuit community totaled seventeen members, nearly a 1:1 ratio with its first student body. For admission, applicants "must know how to read and write, and not be under ten years of age;" An early decision to enroll only white students indicated that Gonzaga was no longer interested in Indian tribes.

Day students were first enrolled at Gonzaga in 1889, and a new church and boarding facilities, "complete with electricity," were constructed tin 1892. Gonzaga was incorporated and legally empowered to grant degrees in 1894. By 1900, Gonzaga's faculty and staff of 24 was

instructing 244 registered students. Both classical and commercial studies were offered. The classical program offered classes in philosophy, rhetoric, poetry, and humanities. The commercial course, stressed essential business management skills.

## My opinion

It all seems simple. So, what is there to be puzzled about? Here are some examples:

Why did any schools open as men's colleges when most of the colleges in the rest of the country were already coeducational? Perhaps this was because so many of the western schools were founded by religious organizations to train men to be ministers.

Why did the University of California at Berkeley open as a men's school and then admit women just one year later/ Did the membership of the Board of Regents change? Did the Board hear a howl of protest and decide they had made a colossal mistake?

Why did the people of San Francisco open a women's college (Mills) before there were any schools for men in the area? Did they assume their sons would inherit their businesses and not need a formal higher education?

Why did the University of Santa Clara wait 110 years after it opened before it admitted women students?

With all of this uncertainty, I find it difficult to assign a male culpability index. I equivocate and assign an index of 5.

# 8. The Jobs Men didn't want
## (late 1800s to early 1960s)

*I want to urge women to go in for original work in research - no longer to be merely hands for another brain.* said Gertrude Klein Peirce Easby of the University of Pennsylvania (www.archives.upenn.edu

Most of the jobs open to women in the late 1800s to 1960s were jobs that no self-respecting man would do. We discuss this issue in seven sections: the majority of women's jobs in the 1800s; jobs for a few women in the 1800s and early 1900s; the nature of post-World-War II America; Women's jobs in 1950; Education that women sought in 1950; reactions to women's work; and Consequences for the future. We finish with my opinion.

## The majority of women's jobs in the 1800s
The 1870 U.S. Census survey showed that there was at least one woman in each of 338 classified occupations, though 93 percent of all women workers fell into the following seven categories: domestic service, agricultural laborers, seamstresses, milliners, teachers, textile mill workers, and laundresses.

By 1900, new technologies opened up other jobs to bright women who had only a limited education — typists and telephone operators.   The first practical typewriter

was invented by Christopher Latham Sholes and was marketed by the Remington Arms company in 1873.

Telephone operators were needed because early telephones in houses and businesses were connected only to switchboards. Anyone who wanted to call someone had to dial the switchboard, give the name and/or phone number of the person to be called, and ask the operator to plug in the appropriate lines to make the connection. Even when the call was completed, the phone was not a place to discuss sensitive matters. Operators could always listen to the call, and many phones were connected on party lines, which let anyone else on the same line hear what was said,

Despite the restriction in the types of jobs open to women, the growth of women in the workforce contributed to social awareness that education might better prepare them to work. During the Civil War women had become more active in philanthropic causes: they made bandages, helped care for the wounded, and knit garments.

But what kind of education? The only profession that required education was teaching, and that was provided by a few years (commonly not a degree), at a "normal school" (Chapter 2). Women who wanted to go to college but not become teachers were directed to programs in "domestic science" (home economics).

The first professor of domestic science at Illinois Industrial University thought that women's education, "must recognize their distinctive duties as women - the mothers, housekeepers and health keepers of the world - and furnish instruction which shall fit them to meet these duties." For this purpose, the school gave

women a "liberal and practical education, which should fit them for their great duties and trusts, making them the equals of their educated husbands and associates, and enabling them to bring the aids of science and culture to the all-important labors and vocations of womanhood."

Domestic science programs were quite rigorous at some colleges. For example, the University of Illinois required a four-year program that included:

*First year:*
First quarter: Chemistry, Botany, British Authors.
Second quarter: Chemistry, Advanced Botany, American Authors.
Third quarter: Free-hand Drawing, Entomology, Rhetoric.

*Second year*
First quarter: Chemistry of Foods, Physiology, German.
Second quarter: Principles of Cooking, Zoology,German.
Third quarter: Domestic hygiene, Architecture, Drawing, German.

*Third year*
First quarter: Projection drawing, Ancient history, German or French.
Second quarter: Physics, Medieval history, German or French.
Third quarter: Physics, Modern history, German or French.

*Fourth year*
First quarter: Household Esthetics, Mental Science, Constitutional history.
Second quarter: Household science, History of civilization, Home architecture.
Third quarter: Domestic economy, Usages of Society, etc., Political economy, Landscape gardening

A similar program was offered at Iowa State University (www.iastate.edu). The wife of the President of Iowa state University established the Domestic Science Department (now Family and Consumer Science) In her first classes she said: "I come to you young ladies not for the purpose of offering formal scientific lectures, but to offer you if I am able, some instruction in the art of housekeeping or house governing. If, from the store of my experience, you can gather that will aid you in your future duties as a truly domestic and useful woman, I shall be fully repaid for any trouble I may take."

In addition to studying how to be better housewives, women were also encouraged to study to be teachers. The reason was simple — money

Women teachers were willing to work for low wages and to accept seasonal employment. As men deserted the teaching profession for better paying jobs in industry or to take up western homesteads, women were happy to get the teaching jobs.

At the University of Missouri (www.missouri.edu), the "Normal College," now the College of Education, was established in 1867 to prepare teachers for Missouri public schools. It enrolled the University's first female students. Women were not admitted to all academic classes until 1871.

Many women realized that they would also need a better education in order to work as secretaries or in other positions in companies. An example of a school that offered these services is Bay Path College (www,baypath.edu), which was founded in 1897 in Springfield, Massachusetts as the coeducational Bay

Path Institute offering teacher training, secretarial science, business administration, and accounting.

# Jobs for a few women in the 1800s and early 1900s

Some women didn't want to be teachers, secretaries, or stay-at-home housewives. They undertook an enormous variety of occupations, including writing, science, and agitating

## Writers

Women writers were so numerous in the nineteenth century that we can mention only a few,

Louisa May Alcott published *Little Women* in two volumes in 1868 and 1869. The novel follows the lives of four sisters — Meg, Jo, Beth, and Amy March — and is loosely based on the author's childhood experiences with her three sisters.

The Bronte sisters — each wrote novels as they lived at their parent's' home. They include: Charlotte's novel *Jane Eyre* (1847), Emily's *Wuthering Heights* (1847), and Anne's *The Tenant of Wildfell Hall* (1848)

Willa Cather enrolled in the University of Nebraska in order to become a chemist. She switched to English, however, when her professors noticed that she was an excellent writer. She edited the student newspaper until she graduated in 1894. Then she moved to New York and began to publish a series of novels about the western frontier. She won a Pulitzer Prize in 1922.

Emily Dickinson was born in Amherst, Massachusetts, in 1830. She attended Mount Holyoke Female Seminary

but returned home after one year. Throughout her life, she seldom left her house.

Julia Ward Howe was born in New York City in 1819. She was self-educated and published numerous poems, including *"The Battle Hymn of the Republic."* One comment attributed to her is "Hope died as I was led unto my marriage bed."

Harriet Beecher Stowe published *Uncle Tom's Cabin* in 1853 and fueled the anti-slavery movement.

## Scientists

The following list shows the most prominent American women scientists of the 19th century.

Sara Josephine Baker, doctor who pioneered child hygiene
Florence Bascom, geologist
Elizabeth Blackwell, doctor (see Chapter 2)
Emily Blackwell, doctor
Mary Layne Brandegee, biologist
Elizabeth Knight Britton, biologist
Mary Whiton Calkins, psychologist
Annie Jump Cannon, astronomer
Mary Agnes Meara Chase, biologist
Cornelia Clapp. zoologist
Agnes Mary Claypole, biologist
Ediith Jane Claypoke, biologist
A. Grace Cook, astronomer
Clara Eaton Cummings, biologist
Florence Cushman, astronomer
Lydia Maria Adams DeWitt, pathologist
June Etta Downey, psychologist

Mary Anna Palmer Draper, biologist
Alice Eastwood, biologist
Rosa Smith Eigenmann, biologist
Margaret Clay Ferguson, biologist
Alice Cunningham Fletcher, ethnologist
Harriet Boyd Hawes, archaeologist
Margaret Lindsay Murray Huggins, biologist
Ida Henrietta Hyde, biologist
Marcia Keith, physicist
Helen Dean King. biologist
Christine Ladd-Franklin, psychologist
Henrietta Swan Leavitt, astronomer
Sarah Plumber Lemmon, biologist
Margaret Eliza Maltby, physicist
Antonia Caetana Maury, astronomer.
Carlotta Joaquina Maury, paleontologist
Maria Mitchell, astronomer
Edith Marion Patch, biologist
Florence Peebles, biologist
Mary Engle Pennington, chemist
Ellen Swallow Richards, industrial and environmental chemist (Chapter 2)
Emily Roebling, civil engineer
Rena Florence Sabin, anatomist and public health official
Nettie Stevens, geneticist
Sarah Frances Whiting, astronomer and physicist
Mary Watson Whitney. astronomer
Anna Winlock. astronomer
Anne Sewell Young, astronomer

We can use two schools as examples of the early education of women scientists.

North Carolina State University. By the 1903 - 1904 academic year, 200 women were enrolled in summer school. they included: .Evelyn Byrd Lawrence of Raleigh, who took a course in architecture; Ivey Roberts of Raleigh, who took a course in drawing; and Frances Claire Stainback took courses in chemistry and English.

By 1921, Lucille Thomson of Wilmington was the first woman to enroll as a regular student. She majored in electrical engineering but did not graduate.

In 1927, The first degrees awarded to women at NC State were given to: Mary E. Yarbrough, the daughter of Louis T. Yarbrough (Class of 1893). She graduated from Meredith College before earning her M.S. degree in chemistry at NC State. She continued her studies at Duke University, where she received a Ph.D. in 1941. Yarbrough spent her entire career at Meredith College as a professor and the head of the Department of Chemistry and Physics from 1941 to 1972. Dr. Yarbrough, also became the first woman to serve as an officer in the General Alumni Association of NC State.; Jane McKimmon, who received a B.S. in business administration; and Charlotte Nelson, who received a B.S. in education

Carleton College. in the late nineteenth century Carleton was one of the leading producers of women B.S. and M.A. degrees in Astronomy. It was also tied as the largest producer of women Ph.D.s. Carleton did this despite having a curfew for women, who needed special permission to do astronomical observing. Graduates include:

Sidney Carne Wolff, who became director of the National Optical Astronomy Observatories.

Anne Sewell Young, who graduated in 1892, was the only astronomer in the first fifty years of Carleton to be listed in Who's Who and one of three to be in American Men of Science. She eventually became the director of Mount Holyoke Observatory.

## Agitators

Because of the repressed condition under which they lived, almost all women were agitators for large or small causes. Most were domestic issues — "I can't feed the family unless you bring back more coal for the stove." These complaints are not recorded, and we necessarily restrict ourselves to the public agitators. They include:

Jane Addams was concerned about the lives of poor people. She founded Hull House in Chicago to help the indigent. Her model spread to other cities, and she became a nationwide advocate for helping poor people. Addams graduated from Rockford College (Chapter 5).

Susan B. Anthony promoted voting rights for women and helped found the suffragette movement. We discuss her activities and the 1848 Seneca Falls Declaration of Sentiments more completely in Chapter 2.

Dorothea Dix launched a nationwide campaign to improve conditions for mentally ill people. She found people in prisons and in mental institutions that were about as bad as prisons.

Carrie Lane, later known as Carrie Chapman Catt, became known as the person who helped organize the women's militia at the University of Iowa (Chapter 6).   Later, she was one of the pioneers of the Women's Suffrage Movement and the founder of the League of Women Voters.

Mary Lease was born in Pennsylvania as Mary Elizabeth Clyens and lived in Wichita, Kansas after marrying Charles L. Lease, a pharmacist, in 1873.   In 1885 Lease was admitted to the bar, and in 1888 she spoke before the state convention of the Union Labor party, a predecessor of the People's party in Kansas, and was the party's candidate for county office long before women were eligible to vote
Lease was an effective campaigner for the candidates of the Farmers' Alliance- People's party during the 1890 election.  During the campaign she was often mistakenly called Mary Ellen, and her enemies dubbed her "Mary Yellin."   During a speech in Halsted, Kansas, she said "What you farmers need to do is raise less corn and more Hell."

Louise Pound, enrolled at the University of Nebraska in 1892.   She helped organize a girls' military company and she set a record at rifle target practice.  She was the first woman named to the Lincoln Journal Sports Hall of Fame in 1954.  While she was at Nebraska, the journal *Physical Education* (a publication of the YMCA) devoted an issue to women, saying that women needed physical strength and endurance and refuted the popular idea that women are too weak to exercise.

# The nature of Post-World-War II America;

Yawn.

The war was over! Millions of men came home and were no longer in danger of being killed at any moment.

The depression that some people feared would come with the end of the wartime economy didn't happen. Factories shifted from making bombers and tanks to making passenger planes and refrigerators.

And people bought them because the country was prosperous. What wasn't bought at home was sold abroad because the world's bombed-out countries had no industry. These countries rolled out moth-eaten red carpets for visiting American businessmen.

America was the unchallenged leader of the world. All of the former world powers had been destroyed. We could do anything, including rearrange foreign governments and economies — all backed by military power, of course.

So, there were plenty of jobs for the returning men. In some positions there were more jobs than applicants. In the 1950s, even a newly minted PhD from Caltech got his dream job because he was the only applicant.

Life was good for men. They went to work and came home to hot dinners fixed by their stay-at-home wives. If their wives didn't like this, tough! They would be good little girls and do what they were told.

By 1952, Uncle Ike (aka President Eisenhower) was elected because some people thought that he had single-handedly won the war in Europe. He smiled benignly on this prosperous America, which seemed to have no major problems.

There was the Cold War and the growing power of the Soviets, of course. The hydrogen bomb. Smog from American industries. But nothing to get worked up about.

Yawn again.

When Johnny came marching home from the war, Rosie the Riveter was supposed to quit her job, go home, and take care of the family.

Some women wanted to continue working after the war, but job openings were in traditional women's jobs. The more fortunate women were in "pink collar" positions, including secretaries, waitresses, or in other clerical jobs. Those jobs were not as well paid as the jobs they had held din the war, and they were not as enjoyable or challenging, but women took them because they either wanted or needed to keep working.

Leaving the work force was fine with some women but not with others. For example, a University of Oregon graduate complained that she used to drive home from work at 5:00 but now had to drive to the train station at 5:00 to pick up her husband when he returned from work.

Many other women felt the same way, but by 1950, five years after the war, women and men had begun to sort themselves out.

## Women's jobs in 1950

What were women doing in 1950? More or less what they had always done before the war. They were working as nurses, secretaries, retail salespersons.

domestic aides, cleaning ladies, hairdressers, and other similar positions. The number of women working as teachers in lower school grades increased as men left for better-paid positions. For many women, these jobs were temporary until their husbands could finish school and begin earning money.

The U.S. Bureau of Labor Statistics (BLS) reports several types of data about employment at all years on the website www.bls.gov. The following reports show changes in women's participation in the last half of the 20th century:

In 1950 about one in three women participated in the labor force. By 1998, nearly three of every five women of working age were in the labor force. Among women age 16 and over, the labor force participation rate was 33.9 percent in 1950, compared with 59.8 percent in 1998.

63.3 percent of women age 16 to 24 worked in 1998 versus 43.9 percent in 1950.

76.3 percent of women age 25 to 34 worked in 1998 versus 34.0 percent in 1950.

77.1 percent of women age 35 to 44 worked in 1998 versus 39.1 percent in 1950.

76.2 percent of women age 45 to 54 worked in 1998 versus 37.9 percent in 1950.

51.2 percent of women age 55 to 64 worked in 1998 versus 27 percent in 1950.

8.6 percent of women age 65+ worked in 1998 versus 9.7 percent in 1950".

**Education that women sought in 1950**

The 1950s was a period of transition for such traditional women's jobs as nursing, teaching, and secretarial work. We are accustomed now to the requirement that nurses and teachers have college degrees and secretaries have training in computer technology. Requirements were much smaller before the war and into the 1950s. We trace the evolution of each of these professions by looking at three different colleges. The first is Stevenson College, Maryland (www.stevenson.edu). We use it to show the development of secretarial training. It began as Villa Julie and has the following history:

In 1947, Villa Julie Secretarial School was founded by the Sisters of Notre Dame de Namur (the same organization that established the College of Notre Dame de Namur in California; Chapter 7).

In 1952, the school became a two-year college

In 1958, Villa Julie College for women was incorporated by the State of Maryland.

In 1965, State approval was awarded for Villa Julie's child development program. Transfer programs were offered in the Arts & Sciences, and in Teacher Education.

In 1972, Villa Julie College became co-educational.

In 1984, Villa Julie offered its first Baccalaureate degree in Computer Information Systems

In 1985, Villa Julie expanded its degree programs to include a bachelor's degree in Paralegal Studies.

In 1988, Additional Bachelor's degrees programs were offered in Administrative Science, Computer Accounting, Liberal Arts and Technology, and Business Information Systems.

In 1988, Saturday classes were first made available for working students and the school became a four-year college.

In 1992, Villa Julie launched ATEC (Center for Advanced Technology and Competitiveness), its first Graduate Program.

In 1996. The Maryland State Department of Education approved programs designed to prepare elementary and early childhood teachers. That same year, the College received the endorsement of the Maryland Higher Education Commission for a Master of Science degree in Advanced Information Technologies.

In 2008, The Board of Trustees voted to change the name of Villa Julie College to Stevenson University.

In 2009. The college created new schools within the College of Arts and Sciences. The schools are: Art, Business Communication, Film, Video, & Theatre , Science, Mathematics, Nursing , Psychology, English, Human Services, Humanities and Public History. The Department of Education was in a separate school.

The second school is Castleton College in Vermont (www.castleton.edu). We use it to show the development of teacher training.

In 1867 the State Normal School was founded in Castleton. For a few years it was housed entirely in an old Medical College building and shared faculty with the Castleton Seminary before that school closed.

By 1950 the curriculum had increased from a few courses dealing largely with methods of teaching to all the subject-matter branches in which public school teachers need information—from how to teach to what

to teach—and enrollment grew to 2,000. The school had developed from one giving instruction at the high school level to a college granting the M.A. degree.

The third school is the Yale University Medical School (www.med.yale.edu). The website includes the following history of nursing education both at Yale and in America as a whole:

In 1900, all nurses were educated in hospitals instead of in schools, and this practice continued throughout the country until the 1950s.

In 1914, Teacher's College of Columbia University began to offer programs in nursing and health.

From 1918 to 1923, the Rockefeller Foundation held meetings on Pubic Health Nursing Education. The final report was published in 1923.

In 1923, the Rockefeller Foundation funded an experiment in nursing education that resulted in the development of the Yale University School of Nursing

In 1937 the first class at Yale graduated with Master of Nursing degrees

It is clear from the preceding discussion that all three areas of "women's work" — secretarial, teaching, and nursing — underwent immense changes during the 1900s. The training that used to be casual and completed in a few years began to require a full college education by the 1950s.

## Reactions to women's work

People opposed to the education of women found much to complain about by the 1950s.

College-educated women did not marry as often as other women. At least one fourth of women who graduated from college never married, more that double the proportion of non-college women. And, if they married at all, they did so later in life, and consequently had fewer children.

Even this limited participation in the workforce prompted heated complaint from some men. Life Magazine published a special issue on women and reached several conclusions, including: "They should use their minds in every conceivable way so long as their primary focus of interest and activity is the home. If they are truly feminine women, with truly feminine attitudes, they accept their wifely functions with good humor and pleasure."

## Consequences for the future

The 1950s prepared America for the revolution of the 1960s (Chapter 10).

Much of the impetus was from women. Many of them felt that their contributions to the war effort had been forgotten and they were now confined to a life of babies, dishes, and happy husbands. They also knew that this confinement wasn't necessary.

Educated women realized that they could earn more by working than they would have to pay less-educated women to take care of their children (Chapter 12). All women knew about the availability of child-care centers and the possibility of leaving their children with friends and relatives. They also knew that they didn't have to be isolated in the suburbs in that cute little house with the picket fence, green lawn, two babies, a dog, and a

woman going nuts because there was no one to talk to except the babies and the dog.

Women also knew that technological advances had made housekeeping much less time-consuming than it had been before the war. TV dinners and other frozen food made dinner easier to fix. Everybody had at least one car, which made shopping easier. Television sets helped to entertain children and husbands.

The attitude of women was documented in a 1963 book by Betty Friedan titled "*The Feminine Mystique.*" After interviewing numerous women, she concluded that women had been "brainwashed" by men into being their servants. She called upon women to educate themselves and become partners with their men rather than second-class citizens.

Friedan's book was in direct contrast to one that had been published in 1947. *Modern Woman: the Lost Sex* by Maryinia Farnhan and Ferdinand Lundgren promoted traditional roles for women. It claimed that most of society's problems, including alcoholism and teenage hooliganism, were caused by women who had careers instead of staying home as housewives and mothers.

## My opinion
I am pleased that the jobs available to women have become far more diverse in the past 100 years. Unfortunately, they required participation of men in duties other than their jobs. Because men were generally not ready to participate in these duties, I assign a male culpability index of 8 to the employment situation of women in the time period covered by this chapter.

# 9. In loco parentis or just plain loco?
## (Late 1800s to 1960s)

*"Tell me, what is it you want to get done after midnight that you can't get done before midnight?"* said the Dean of Women at Radford College when students asked to extend their curfew past midnight. (from www.radford. edu)

The problem was usually the mother. As soon as her daughter mentioned the possibility of going to college out of town, mother began to worry about safety. Would the daughter be attacked? Would she get pregnant — commonly referred to as a "fate worse than death?"

Mother conveyed that worry to father, then her friends, and the daughter's friends. Soon everyone was in a panic, just because mother couldn't believe that her daughter could survive without constant supervision.

Ideally, the supervision provided by the college would include a chaperon whenever the daughter left the dormitory to go anywhere except to class. If this was impossible, and it usually was, then the minimum requirements for safety included both a sign-out slip and curfew. The sign-out slip contained where the student was going, who she was going with (normally her date), and when she expected to return. That "when" could be no later than the curfew imposed by the school.

Women who were late were punished in various ways. The most common one was "campusing,' which meant that the student couldn't leave the dormitory for one or several weeks except to go to class (i.e., no dates). Some punishments included loss of the privilege to use the residence telephone, Some colleges caused lights to blink at the door to the residence when curfew approached.

These rules were called "parietal" and were justified because the college was supposed to act "in loco parentis" (in place of the parents).

We discuss the problems raised by this chapter in three sections: Rules imposed on college women; Effects of parietal rules; and How women got rid of parietal rules. We finish with my opinion.

## Rules imposed on college women

This section contains examples of parietal rules imposed on women. They will amaze anyone born n the past 50 years.

Curfew regulations varied from school to school, but the sign-in hours all were later on the weekends than during weeknights (including Sunday). In almost all, but not quite all. schools the parietal rules became less stringent as time progressed toward the 1960s.

Colorado College
Rules for appropriate behavior of young women were posted inside closet doors.

Curfews were 10:00 during the week and 12:00 on weekends. The dining room served three meals a day

on tables with "snowy linens and red-shaded lamps." Two faculty chaperons had to be present on all social events attended by both men and women. Women were not permitted to smoke or drink on or off campus. Male students sometimes boosted their dates through the dormitories' fire escape windows after curfew.

### Albright
In 1966, women had to wear long coats to cover their shorts.

They were allowed to smoke only in their rooms and one other designated place.

First-year women were allowed to stay out until midnight only one night a month.

One night was added for each year of school.

### Michigan State
A woman graduate recalled "In the 1959 handbook women were referred to as 'women' until it got to the parietal rules (curfew). Then they were called 'girls'. It didn't prevent unwanted pregnancy or inhibit aggressive male students (or non-students) and the female dropout rate was high because of it. Birth control was forbidden for single women and was generally hard to come by for married women also. The policy was for women to marry young and breed early."

### Susquehanna
In 1967 women had seven pages of rules and guidelines for them to follow. Women students had a curfew and had to sign out and sign in. They had a certain amount of times they could exceed their curfew,

depending on class year. Freshmen had eight 12 o'clock permissions per semester, sophomores and juniors had ten 12:30 permissions, and seniors were allowed twelve 1:30 permissions.

Macalester (www.macalester.edu)

The husband of a deceased student recalls "Many are the memories of Wallace Hall [women's residence], with its downstairs "living room" environment; the last few moments spent together in the vestibule before the "witching hour" curfew; and the constant admonition of the house mother not to wear patent leather shoes, lest they "reflect upward!"

Binghamton

In 1966 women in student housing were not allowed to leave the building from late at night until sometime early the next morning. These regulations were imposed by the university in "an effort to prevent premarital intercourse."

Marquette

A woman who graduated in 1956 recalled "Women, led by the Dean of Women, were allowed to go to nice little teas wearing hats with veils and white gloves with pearl buttons. And we females never complained that the men directed every important activity on campus. We wore our skirts and sweater sets and our black flat Pappagallo shoes and smiled. "

Another 1956 alumna recalled "I would date him and I have to admit that I think the curfew for was something like eight o'clock, maybe it was even seven o'clock. We

didn't have a lot of leeway. When I had a date I actually would sneak in and stay out later. A friend would either open the door for me or prop it open so I could get in. "

Furman
Since freshmen women were only allowed in two places, their room or the library, from 7 p.m. until curfew at 11 p.m., many chose to visit the library.

Brockport
Regular hours:
Weekdays: 12.30pm.
Saturdays: 1.30am.

Augustana
"Help, police! Isn't this wonderful." cried some women students out of windows during a raid by men on the women's building on February 25, 1949.

Vassar
In 1966 Vassar college extended curfews for seniors returning at night by car to 2:30 AM on any night of the week, provided that the individuals return accompanied by another person, and extended the hours during which resident students were permitted to have men in their rooms.

Utah State
In 1959 women were not allowed to wear slacks in class.

University of Pennsylvania

Women were not allowed in the men's dormitories, and men were not allowed in the women's residence. Curfews were 11 p.m. during the week and 1 a.m. on weekends.

### Radcliffe
The college explained Underlying Reasons For A Curfew in 1966. They included the observation that curfews at other colleges were stricter than those at Radcliffe. the necessity of supporting the values of parents, the standards of conduct expected by the public, and the fact that some immature students needed protection.

### Ohio Valley University
12:00 curfew on Sunday to Thursday; 1:00 am curfew on Friday and Saturday; no curfew for juniors, seniors, and women 21 years old.

### Pepperdine
In the 1930s there was no dancing, no members of the opposite sex in the dormitories, no shorts or beachwear in the classroom and a long fence to separate the lower men's dorm from the women's dorm. In the women's dormitory, the women were closely watched (by the house mother and the "boys could do as they please."

In the 1930s, 1940s and 1950s seniors could live on the ground floor of dormitories, but freshman had to live on the upper floor so they wouldn't try to crawl out of windows after curfew. When men visited during open houses, room doors had to be open by the width of a bible.

Macalester alumni stories (www.macalester.edu)

"My favorite memory was 105 girls in Bigelow Hall trying to get along; trying to keep a 10:30 p.m. curfew and a general lock-down on weekends. Amazingly, most of us survived, only a bit scathed. The fact that we still like and admire each other is a testimony to a good school and education."

Climbing in the lower back window of Bigelow Hall dorm, not an easy thing to do, even at our very young age. I don't remember whose room it was, but I'd like to thank them.

We were scandalized when an older dorm girl was grounded for her unladylike behavior."

Millsaps (www.millsaps.edu)

First-year women had numerous regulations. At night, they could not go near the men's dormitories or on the golf course. One alumna remembers

"Perhaps the signout card was what gave me my start in fiction." Also "Under our skirts, even those of us who barely topped 100 pounds, we wore full body armor — stockings hooked to a very tight girdle — because it was considered tacky in the '60s for girls' posteriors to jiggle.
"

Wayland Baptist, Utah (www.wayland.edu)

When the curfew was 8 p.m. Monday through Thursday and 10 p.m. Friday through Sunday, some students kept a rope ladder in their second-floor room and could use it to climb in and out after curfew

Douglass (www.rutgers.edu)
Pregnant women had to leave Douglass even if they were married.

State University of New York at Buffalo( www.buffalo.edu)
Women had to dress up for the noon meal on Sunday.

Mt. St. Mary (www.msmc,edu)
Curfew hours were
Sunday—Thursday: 1:00 a.m.—6:00 a.m.
Friday & Saturday: 3:00 a.m.—6:00 a.m.

Ohio University (www.ohio.edu)
Rules included:
Women who wore Bermuda shorts had to wear knee-length socks.
All students needed a written excuse from the infirmary to miss Saturday morningclasses.

Bucknell (www.bucknell.edu)
Women were not allowed to wear slacks downtown or to class, even on the coldest days.  Women had a sit-down dinner with linen napkins.  Curfews were 8:00 pm.

Barnard (www.barnard.edu)
Students who had male visitors had to keep their doors open the width of a book. They used a matchbook.
The website reports that In the spring of 1968, Linda LeClair, a Barnard sophomore "became nationally known when she defied college housing rules by moving off campus to live with her boyfriend."  Time magazine

published an article about her and included a picture of her apartment. In a letter to the editor published in Time magazine on May 10, 1968, Hariette Wagner of Northbrook, Ill. wrote: "I don't know what kind of student Linda LeClair is or what kind of a mistress she makes, but judging from the picture of her apartment, she makes one lousy housekeeper. Doesn't Barnard College have a Home Economics department?"

Muhlenberg (www.muhlenberg.edu)
Some faculty members were hostile, to women students. One asked "what's a pretty girl like you doing here? You should be married."

Drew (www,drew.edu)
An alumna reminisces: "The institution as surrogate parent. Explain that to a student today, and you'll get a look like you just walked in from the 13th century. Yet by the time I graduated in 1970, the university was closer to coed dorms than women's curfews, and the conduct policy had pretty much become "whatever." The merits of those changes can be argued."

State University of New York at Albany (www.albany.edu)
In 1969, freshmen women had curfews at midnight. Even though sign-outs were not required, all women could use them if they wished.

University of Massachusetts. Amherst (www.umass.edu)

Curfews were 7:00 PM Sunday through Thursday 11:00 on Friday and Saturday.

Mt. Holyoke (www,mtholyoke.edu)
In 1965, curfew was 11 p.m. on weekdays, midnight on Friday and Sunday, and 1 a.m. on Saturday. Depending on seniority, students had some extra late hours they could take any night of the week. Overnights were permitted only 6 times for freshmen the first semester; 8 the second; and unlimited thereafter. Cars could be kept only by students with a B- or better average for two semesters running or seniors after spring vacation. Freshmen and sophomores could have cars part-time for special reasons. Dates' cars were legal vehicles.

Carthage (www.carthage.edu)
In the 1950s women would get around curfew by climbing out of windows and climbing down trees. Couples also had to keep three feet on the floor when sitting on couches. One graduate recalls "laughing, dancing, loud music, lots of movies, too much candy, and who knows how many times breaking the curfew kept us all sane and in good spirits!"

Eastern Washington (www.ewu.edu)
1959 women graduates reminisce "Dorm curfew which I never minded - a chance to end an uncomfortable date!"
"Blinks at 10:15 Monday through Thursday; 1:30 a.m. on Friday and Saturday nights and Sunday was 11:00 p.m. Fun times in the lounge at night!"

Westhampton (www.westhampton.edu)
At Westhampton College in the 1950s, men lived on the northern side of Westhampton Lake and women lived on the southern side.
Women had to be in their dorms by 7 p.m.; men didn't. Men were allowed to have cars; women weren't allowed to have them until their senior year.

Marymount (www.marymount.edu)
One alumna remembers "The sisters emphasized discipline and there "seemed to be a lot of rules that I didn't appreciate then, but now, as a mother, I surely do!"

Clemson (www.clemson.edu)
In 1971, first -semester freshmen women were the only students required to have a curfew. Women who had written parental permission were exempt from curfew.

Texas Women's University (www.twu.edu)
In the late 1960s and early 1970s. "Students started to press the administration to "consider students as adults, not as children of the University,""

Duke (www.duke.edu)
Alumnae note that "There seems to be a misperception [among modern students] that the college was "holding women back" and set a stifling social environment of rules and early curfews behind locked dorm doors. But inside the dorms, all the doors were open, and people spent most of their time in the hallways or commons

areas." And. "living in dorms with upperclass women was the most valuable experience, The seniors served as mentors to us and instilled in us a lot of strong values and expectations."

## Effects of parietal rules

The effects were both good and bad. Most women chafed at them, and some found ways to get around them (see Wayland Baptist and Carthage in the preceding section). Conversely, some women liked the curfews for various reasons (see Eastern Washington and Duke in the preceding section.)

There are also studies that show that students who have a curfew in their first year in college do better than those who do not,and the drop out rate is much less for students who have a curfew than students who do not,"

The most eloquent testimonials for parietal rules come from former students at St. Mary's College of Indiana, which is adjacent to Notre Dame. They consist of letters to Sister Basil Anthony on her 90th birthday. They include:

"When other colleges were in turmoil during those difficult late 60's, we students had the benefit of working with you and other wonderful members of the faculty and administration."

"In my day, oral tradition at Saint Mary's had it that you had single-handedly stopped a panty raid. One warm night, hundreds of restless Notre Dame students had descended on Holy Cross Hall to perpetrate some mischief. As they tried to enter the dorm, you purportedly met them at the front door and uttered one short phrase,

"Over my dead body!" They turned as one and ran back to their own campus. I can picture it all in my mind, and it still brings a smile to my face."

"Congratulations, Sister B.A.! What a lot of memories we all have of you, especially the ones where you stood at the sign-in desk watching over us. Thanks for all the watching. It kept some of us on the straight and narrow, some of the time. P.S. I never was responsible for painting the water tower. I don't like heights. But I think I told you this in 1966.

Another good effect of curfews was that it reduced, but did not eliminate, the possibility of rape. Some colleges now are giving instructions about rape defense. One is Belmont Abbey:

Belmont Abbey Rape Aggression Defense ( RAD ) Program:
"The RAD program is a twenty-hour course created to instruct women on how they can protect themselves against attack and abduction. The course is sponsored and taught by certified Campus Police officers.

Safety programs include: Whistles and instructions on how to use them; sexual assault and how to deal with it; and underage and binge drinking."

George Mason College provides warnings about safety:
It is estimated that 1 in 3 American women will be sexually assaulted in her lifetime.

89% of sexual assaults are committed by someone the victim knows.

Approximately 1 in 10 high school students has experienced physical violence in dating relationships. Among college students, the figure rises to 22%.

Recreational use of alcohol and other chemical substances on campus remains high (75% of men and 55% of women involved in acquaintance rape had been drinking or using drugs just before the attack).

The most frequent sites of rape are in campus residence halls.

## How women got rid of parietal rules

Parietal rules disappeared for a variety of reasons, and we show three examples here.

William and Mary (www.wm.edu)

In 1972 the Virginia General Assembly passed a law giving 18-year-olds the rights of adults, and the College had to abandon all parietal rules. This decision followed a "Burning of The W&M Woman," in which men marched to the women's residences and encouraged women to burn their copies of the etiquette manual.  In October 1969, the Student Association staged a dorm-in, with women entering men's dorm rooms in protest of a curfew forbidding them from doing so.

Albright (www.albright.edu)

In 1969, students took over the library to protest many College policies, including some of the rules for females. A compromise reached during the sit-in released junior and senior female students from curfew with written parental permission, and established dormitory open

houses on Sunday afternoons so that male and female students could visit each other during that time.

Franklin and Marshall (www.fandm.edu)
In early November, the College Administration completely abolished the curfew rules for the women's residence hall after a series of protests. "Although the administration's decision to eliminate all curfew rules for Marshall Hall probably did not sit well with parents, students learned early in their college careers that protesting can often achieve a good result."

## My opinion
That's over! And, in the early 21st century, it's not coming back. I'm not sure whether I'm glad or sorry that parietal rules are gone.

A woman student at the University of North Carolina was recently abducted and killed in the middle of the night. Friends asked me if that would have happened if the university required all women to live on campus under curfew. Also, should the university establish such policy? I answered no and no. Of course women wouldn't be killed in the middle of the night if they were locked up in their residences. But there was no way that such a policy could be adopted now.

My attitudes were also shaped by my experience as Master of Brown residential College for women at Rice University from 1966 to 1971. I remember talking to a senior who was living under curfew when I first arrived. She told me that she was going to Africa with the Peace Corps after she graduated, and I wondered why on earth she should have a curfew now.

On the other hand, I saw an extraordinary increase in maturity from first-year students to seniors.  I was pleased that the members of Brown College retained curfews for first-year students as they abolished them for everyone else.  Naturally, by the time I left in 1971, curfews had disappeared for everyone.

My experience may have particularly attuned me to the central problem of different treatment of women and men.  Women get pregnant, and men don't.  This obvious fact seems to be overlooked in the pursuit for equality of women and men.  We investigate this issue more completely in Chapter 12.

Although male college administrators approved parietal rules. the regulations were actually enforced by house mothers and required by mother's of the students.  For this reason, I assign a male culpability index of 3 to the issues covered in this chapter.

# 10. Revolution
## (1960s)

Consider two possible conversations between Lulubelle and Hunk in the mid 1960s. Lulubelle and Hunk are college students, and the conversations are in Hunk's apartment as Lulubelle takes off her clothes.

*The conversation that Hunk wanted to have.* Hunk says "Lulubelle, I have a terrible draft number, and the army is going to draft me and send me to Vietnam if we don't get married and get you pregnant soon." Lulubelle replies "I'll stop taking my pills now, and at the rate we are screwing, I should be pregnant in a month."

*The conversation as it probably went.* Hunk says "Lulubelle, I have a terrible draft number, and the army is going to draft me and send me to Vietnam if we don't get married and get you pregnant soon." Lulubelle replies "I can't do that. I have another year until I graduate and go to law school," Hunk says "You don't care if I get killed. If that happens, you'll just slip your little body beneath another guy. "If all I mean to you is a draft exemption, then maybe I'd better find that guy now." says Lulubelle as she puts her clothes back on and walks out of Hunk's apartment.

This chapter discusses the "revolution" in six sections: the nature of the 1960s; teach-ins; drugs; the contraceptive pill; confidence and the new woman; and an effort to establish a coordinate woman's college in the 1960s. We finish with my opinion.

## The nature of the 1960s

The chaos of the 1960s grew inevitably out of the easy good life of the 1950s (Chapter 8). By 1960, however, people began to realize that they would have to work harder and harder to maintain that good life. People understood that it wouldn't be easy for America to be anything it wanted to be; do anything it wanted to do. They began to acknowledge that the spiritual and material resources of the country had been consumed at a wasteful and exhausting rate.

One reaction to this understanding was to look for scapegoats and deny that all Americas were responsible. The first scapegoat was the planets, or the stars, or whatever that had ushered in the "Age of Aquarius," This phenomenon proclaimed that mankind had been released from the old bondage of convention and externally mandated responsibility. No longer did a man have to work to bring home enough money to feed his family. No longer did a woman have to comfort a crying child. No indeed! People were now free. People were now free to choose their own lifestyles, to act responsibly or irresponsibly as they saw fit.

This idiocy was bolstered by the war in Vietnam, the war the government always said we were "winning." But as the 1960s progressed, it became more and more obvious that we were losing. People who heard the

government's cheery pronouncements on the news broadcasts visited their neighbors and said "It's all lies." The word "lie' spread through the country, and people talked vaguely of "revolution.' But who would we revolt against? The liars in the government had been elected by the people or appointed by those who had been elected. How do you revolt against yourself?

People finally decided to revolt against the "establishment." It included the national government, local governments, big business, and particularly among students, the leaders of colleges and universities. Many college presidents who disagreed with national policies were surprised to find themselves tarred by the same brush that students used on the government.

The chaos of the 1960s was enhanced by the Jesus freaks and the drug freaks. Their message was "Experience! Feel! But do not think." The Jesus freaks encouraged people to read the book of Revelation and prepare for salvation. Some of the people who read it abandoned their jobs, their homes, and their families in order to prepare themselves for the 'next life," which presumably would be better than this one.

The drug freaks were worse. They pushed drugs that could make you feel, for a time, that the world was a glorious place. They neglected to tell people of the medical consequences of taking the drugs.

I remember the 1960s well. From 1966 to 1971 I served as the Master of Brown College, one of the residential colleges for women at Rice University. My family and I lived in a house next door to 200 wonderful women. While I was there the "Age of Aquarius (whatever that was) arrived, protests over the Vietnam war accelerated,

and both good and bad principles that had formerly ruled U.S. society seemed to break down.

There was no email at that time, but I was bombarded by phone calls and letters from parents who wanted to know why their children were, in their view, misbehaving. Also, they wanted to know what I was going to do about it. I developed a generic response to most queries — something like "People of all ages react to the society around them, and those of college age may be even more sensitive than others. If they see their elders, particularly those in positions of authority acting like idiots, then the students will too. So get off my back and take care of your business." This message was not always well received.

## Teach-ins

One of the most important aspects of the 1960s was campus protests ("teach-ins" against the Vietnam war, They were similar at most colleges and universities.

They were generally held outside. Although the subject — the Vietnam war — was serious, the activities were generally disorganized. Faculty members and students would grab the microphone as the spirit moved them. Comments were full of profanity. Hatred was spewed out against both the U.S. government and the administration of the college. The sweet smell of pot added a sense of unreality to the event, and some people had to be hospitalized.

The teach-ins were generally peaceful, but some became violent. Students occupied administration buildings and demanded action. Damage was generally

minor, but some offices were occasionally trashed. On rare occasions. students set fire to buildings.

The minor violence caused many administrations to overreact. I remember that one school administration asked the coach of the baseball team to have his players bring bats in case the crowd became violent. The Chairman of the Board at one school said the he "wanted to get a firm hand on the tiller," and one of the women students replied that she wanted the chairman to "get his hand off my tiller."

The University of Michigan (www.umich.edu) claims to have been the first university in the country to start teach-ins.

On March 24, 1965, a particularly violent protest erupted after President Lyndon B. Johnson ordered the bombing of North Vietnam. The president's escalation of the war outraged many professors who had worked hard for his victory in the 1964 election. By March 1965, many faculty members believed it was time to act against the war. Faculty members proposed a twp-day strike or "moratorium" during which faculty protesters would refuse to teach classes and instead devote the day to teaching interested students about US involvement in Vietnam.

The Governor and State Senate of Michigan condemned the moratorium and wanted involved faculty members punished. Then some faculty members suggested that rather than refraining from teaching they should hold special lectures and classes at night. The University administration gave its support to the teach-in, permitting school auditoriums and public

address equipment to be used for the event. Curfew for female students attending the late-night teach-in was suspended, helping both to boost attendance and convey to students the importance of the event.

At the end of the 1960s, some people still thought that the country would soon return to "normal." That possibility ended dramatically on May 4, 1970. Authorities at Kent State University, Ohio, called the Ohio National Guard to stop a student protest. The situation soon got out of hand, and members of the Guard shot and killed four students. The members of the Guard claimed that they were defending themselves. Students pointed out that this was another abuse of power by the "establishment." Students at schools all over the country rioted in protest.

For example, the website of West Virginia University (www.wvu.edu) reports that
WVU students joined with students across the country and held a vigil to protest the deaths. Ultimately, there was a demonstration lasting three days. The West Virginia police were called in and used tear gas to try to clear students from the area, but the students returned as soon as the gas dispersed. The Chair of the Philosophy Department announced that he was canceling finals for his classes and giving all students in his classes an A for the semester.

## Drugs

The most common drug was marijuana (pot). Many people argued that it was far less dangerous than alcohol. I recall one benefit. Students who were "stoned"

on marijuana didn't throw up when they returned to their residences as did students who were "bombed" on liquor. The popular motto in women's residences when students "checked in on a slab" was "better stoned than bombed."

The drug LSD (lysergic acid diethylamide), commonly known as "acid." was dangerous. It is very easy to make. It was first synthesized by in 1938 from ergotamine, a chemical derived from ergot, a grain fungus that typically grows on rye.

LSD had been popularized by Timothy Leary, a psychologist who believed in the therapeutic benefits of psychedelic drugs. He encouraged the use of LSD for its therapeutic, emotional and spiritual benefits, and even believed it showed incredible potential in the field of psychiatry. He also coined the phrase "Turn on, tune in, drop out."

People who "dropped" LSD would go on weird "trips" in which they would hallucinate and see strange images. Some of the visions were terrifying, and people who lost control of themselves would have to be hospitalized.

## The contraceptive pill

The Food and Drug Administration (FDA) allowed marketing of the contraceptive pill ("the pill" ) in 1960. It immediately became popular with women of child-bearing years as a better means of preventing pregnancy than any of the methods previously available.

Previous methods were inconvenient for various reasons. Condoms were cumbersome to put on during sexual passion and required men to participate in the effort to prevent pregnancy. The rhythm method"

175

permitted intercourse only during the last half of a woman's monthly cycle, between ovulation and the beginning of menstruation. The pill permits intercourse throughout the entire time between menstrual periods

WARNING - this is a highly oversimplified description pf the biochemistry of the pill. The pill prevents pregnancy largely because it contains progesterone, a sex hormone. During a woman's natural monthly cycle, low progesterone concentrations before ovulation permit fertilization of an egg, Rise in progesterone levels after ovulation prohibit fertilization of an egg even if one is still available. The progesterone in the pill keeps progesterone levels high enough before ovulation that no egg can be fertilized at any time.

So, in 1960 it became whoopee time for women nearly all month long. This was generally good, but it had the unfortunate side effect of causing men to assume that all young women were on the pill. Consequently, a woman could not use fear of pregnancy as a reason for not hopping into bed with a man. She simply had to say "no" and leave him offended if necessary.

## Confidence and the new woman

The 1960s gave young women two reasons to feel confident. One was the contraceptive pill, and the other was the feeling of power brought by participation in the student protests. No longer did young women feel subordinate to people in authority.

One of the immediate results was the elimination of parietal rules for college women (Chapter 9). Confidence in other areas, however, was uncertain.

A 2009 thesis by Audrey Fritton of Providence College titled A Comparative Study of Self-Esteem: College-Aged Women vs. Women at Midlife (from digitalcommons. providence.edu)" reported:

A woman's self-esteem, is defined as "a realistic respect for or favorable impression of oneself." Fritton hypothesized that "the intense focus on women's rights and political activism of the 1960's and 1970s would have promoted greater self-esteem in young women of that era, as compared to the largely apathetic culture of present-day young women. " Although women who were college students in the 1960s and 1970s felt more self-confident now, they admitted that they did not feel more confident when they were in college. The levels of self-confidence were similar to those of present college students, who reported that their confidence depended on a variety of external factors, including relationships, appearance, and success in academics.

The Coalition of Women's Colleges (www. womenscolleges.org) has a membership of 68 colleges. The coalition strongly supports the education of women in women's colleges instead of coeducational schools. There are several reasons for this support.

These reasons center around the relative aggressiveness of men. In coeducational classes, men tend to speak more often than women do. Men are more likely than women to take leadership roles on campus. Thus, " women attending women's colleges are 1.5 times more likely to earn baccalaureate degrees in the life and physical sciences or math than women at coeducational institutions."

In addition, women at women's schools feel more self-confident about non-academic issues. Without the constant exposure to men, the women cab relax and "be themselves." The only problem is that students at women's colleges have a less satisfying social life.

So, it is not clear that college-age women really are as confident as men. We discuss the problem of equality and equity further in Chapter 12.

## An effort to establish a coordinate women's college in the 1960s.

A revolution is a bad time to start anything. It was a particularly bad time for Hamilton College, in Clinton, New York, to establish a coordinate women's college. Hamilton was, and still is, one of America's finest undergraduate schools. But their effort to establish Kirkland as a coordinate women's college ended in total failure. The first students arrived at he college in 1968, and the college closed in 1978.

I base the following discussion of Kirkland on a book by Samuel Fisher Babbitt, *Limited Engagement*, published in 2007 by Xlibris. The quote is from the book.

One of the problems was money. Kirkland started without any endowment or alumni base. Although Hamilton paid for all capital expenses, operating revenue was left to Kirkland. Kirkland raised this revenue by a combination of methods. They included borrowing money from Hamilton, seeking donations from people and organizations, and charging tuition of about $3,000 a year.

The financial situation was so bad that in the fall of the 1977-78 year, the last year of operation, Kirkland had only enough money to last until March.

Educational philosophy was also a problem. Hamilton had a typical curriculum of courses, grades, and majors. Kirkland didn't have grades, but used "evaluations" written by both instructors and students at the end of courses. Because Kirkland's curriculum was interdisciplinary, faulty members had to teach in their own fields and "related disciplines." One of the difficulties was science, which Kirkland offered without laboratories.

Kirkland also seems initially to have misjudged the attitudes of college women in the 1960s. There was no organized physical education so that the ladies wouldn't have to get dirty. Dormitories had upstairs rooms where residents could fix their hair and get ready to go downstairs to meet their boyfriends Actually, residents saw no problem with men wandering around all parts of the dorm. The mistakes were recognized quickly, however. "By 1968, when Kirkland opened, the assumptions that underlay these plans had spun 180° on their axis. Not a curler in sight, and who dressed up? And what, the students would ask, is the problem with men in any part of the dormitory?"

When Kirkland closed in 1978, Hamilton absorbed the Kirkland students and faculty and became a coeducational school.

## My opinion

Despite all of its craziness, I think the activities of the 1960s had a good effect on America. They

demonstrated that many of our institutions, both public and private, were flawed. That the men — and they were almost all men — who controlled the institutions did not understand how capable young people were and what they could do if given a chance. The entire process gave young people more confidence in themselves, although perhaps women did not benefit as much as they should have.

Because the revolution was directed at institutions directed by men, and men tried to prevent it, I assign a male culpability index of 8 to the situation in the 1960s.

# 11. Onward to the Brave New World
## (late 1900s to early 2000s)

*One man out of a thousand is a leader. The other 999 follow women.* Groucho Marx.

In order to accommodate the changing demands of women students, colleges and universities tried frantically to change their curricula in the latter half of the 20th century. We examine these changes under four, intertwined, headings: the post-graduation lives that women expected; the names that women applied to themselves; the classes that women didn't want; and new curricula. We finish with my opinion of the situation.

## The post-graduation lives that women expected

In the middle 20th century, few college women could look forward to professional careers. A principal reason for going to college was to meet a husband who would be educated and, therefore, a "good provider" for their wives and families. Although most women pursued a B.A. degree (some even a B.S). the title that most college women sought was MRS.

In the 1950s, some women who already had the MRS worked toward another title. It was the PhT, which stood

for "putting hubby through" as he worked for his PhD degree.

In 1950, about one third of women students left school before they graduated, mostly to get married. In 1950, Lynn White, Jr., the male president of Mills College for women, wrote *Educating Our Daughters*, in which he said that women students should prepare to "foster the intellectual and emotional life of her family and community." He also said that people think that "higher education is something like spinach which can profitably be absorbed without reference to the gender of the absorbent." Because the term "housewife" seemed to be derogatory, many women had the "biologically fantastic notion that to be different from men is to be inferior to men." The male president of Radcliffe College, coordinate with Harvard, told students that if they studied hard and stuck around, they might be lucky enough to marry a Harvard man.

The situation in 1950 began to change rapidly in the 1950s. In 1959, A. W. Zelomek, President of the International Statistical Bureau, wrote *Changing America*. He reported that 40% of women with husbands and school-age children worked outside the home. Almost all of these women however, held clerical, assembly-line, or service jobs.

The change in attitudes is reflected in the Conococheague, the yearbook of Wilson College for women in Pennsylvania.

First, we should note that the 1907 yearbook mentions this sign placed at the door of one of the dormitories:

"Seniors are going fast.  Some choice ones still available. Come early and avoid the rush."

Each yearbook published vignettes about the students at the college.  We compare the descriptions in the 1907 yearbook with those in 1954.

# 1907

*she is always in a good humor and never gets fussed*

*she is believed to have no mean literary ability*

*examples in psychology are her specialty*

*she began to play hockey, but her tender feelings would not permit her to be spoken to in the abrupt language of the field, and thus forced her to retire to her sedentary life*

*sometimes forgets her weariness when she is at the piano*

*she might be termed one of the heart-smashers of the class, for her victims lie strewn behind her*

*her chief claim on our imagination is the fine figure she cuts in a dress suit*

*love has certainly not reached the Il Pensoroso stage yet. however it is safe to predict that if the fever continues to rise at the present rate, delirium will set in*

*she is exceedingly fond of her B's: Note: B may be considered as standing either for boys or books*

*we have a writer of unusual ability — and if she doesn't shrink into oblivion as the wife of one of her numerous admirers we may hear of her later*

*the deepest mysteries of trig lie open to her intelligence*

*her present career, which certainly is unlike any other*

*it is the custom of hers to chase around the country on pleasure-trips while less fortunate mortals are poling strenuously for exams*

*she will make an excellent housekeeper for some man, for her chief delight is to make the dust fly*

*buxom specimen of budding youth*

*she is not apt to do anything to astonish the world, but her sweetness of disposition is likely to prove too great an attraction, and off she'll go to some "love-in-a-cottage" career*

*when one can gain fame by writing quietly at home, what is the use to go chasing over the hockey and basketball fields?*

*We tremble to think what her grades would be if Wilson were co-ed, for if there's one thing she does worship it is a man*

## 1954

*The Honorable ..., Representative from Pennsylvania*

*Meticulous and genteel, with a song in the air*

*A sense of responsibility without the loss of a strong independence*

*Intellectual curiosity (biology major)*

*High standards and the ability to achieve*

*The objective outlook (mathematics major)*

*Neatness, precision, and simplicity (biology major)*

*A capable career woman*

*Fastidious dresser; domestic inclination (economics major)*

*Vast collection of sweaters and skirts; future in merchandising*

*Exotic blonde with inquiring eyes*

*Feet on the ground; head in the clouds*

*To live for others*

*Exploratory hikes with an eye for rocks and animals (chemistry major)*

*Charm radiated through warm eyes and smile (biology major)*

*Tailored clothes (chemistry major)*

*A habit of thinking to the bottom of everything (physics major)*

*Mathematical order and unfailing efficiency (economics major)*

*Belts, Bermuda shorts, and shirts*

*Elementary teaching and a love of children*

*Drawn to the intellectual*

*Graceful movement of the ballet dancer (chemistry major)*

The differences between the women described in 1907 and those in 1954 are clear. In 1907, most of the women seemed to be primarily interested in men. By 1954, many of the women were preparing for careers.

## The names that women applied to themselves;

In the 1950s, college women were glad to be called "girls." The term implied youth and sexual desirability. During the 1960s, the term "girl" was considered to be demeaning, and college women insisted on being called "women."

The names for married women also changed. Some women rejected the traditional practice of taking their husband's last name and kept their own. Some women also objected to the traditional requirement that women be referred to either as Miss or Mrs., thus creating the generic title Ms. I welcomed the title Ms, because it relieved me of the problem of deciding how to address letters to women that I didn't know well. (Actually, I sometimes used the non-gender-specific title Dr.)

We seem to have come full circle in the early 21st century, and even older female graduate students are glad to be called girls.

## The classes that women didn't want

Women did not want programs in domestic science/ home economics. They had been popular in the early 1900s as women prepared for lives as homemakers (Chapter 8). By the late 1900s, however, those programs had virtually disappeared from college curricula.

But, 89 colleges and universities now have departments of Family and Consumer Science. These programs are very close to home economics but are described in different ways. For example, they teach

students to how to juggle the competing challenges of careers and family, how to shop for food and cars, and how to resolve family disputes. Some programs claim that graduates can teach home economics in high schools.

## New curricula

Many women, when freed from purely domestic responsibilities, began to major in the same programs as men. They included liberal arts, and to a lesser extent, science, technology, engineering, and mathematics (the "STEM fields. They also were interested in newly developed programs, such as the ones at Villa Julie and Castleton College (Chapter 8).

Women also diversified into fields not traditionally occupied by women. The U.S. National Science Foundation publishes reports on degrees awarded to women in science and engineering. I compare percentages of women in various fields in 2004 (Division of Science Resource Statistics 2007 report) and in 2008 (Division of Science Resources Statistics, special tabulations of U.S. Department of Education, National Center for Education Statistics, Integrated Postsecondary Education Data System, Completions Survey, 2000—08). The names of the fields are slightly different in the two surveys, and some numbers are approximated. STEM is an acronym for Science, Technology, Engineering, and Mathematics.

| Degree and field | 2004 | 2008 |
|---|---|---|
| *Doctoral* | | |
| All fields | 45.3 | 50.4 |
| All STEM | 35 | 40.7 |
| All Social Science | 55 | 48.5 |
| Biology | 46.3 | 50.8 |
| Geoscience | 33.9 | 35.7 |
| Mathematics & statistics | 28.4 | 35.7 |
| Engineering | 17.6 | 31.1 |
| Computer science | 20.5 | 22 |
| *Masters* | | |
| All fields | 59.1 | 60.6 |
| All STEM | 40 | 45.8 |
| All Social Science | 60 | 55.8 |
| Biology | 58.6 | 58.7 |
| Geoscience | 44.6 | 45.4 |
| Mathematics & statistics | 45.4 | 42.8 |

| | | |
|---|---|---|
| Engineering | 21.1 | 23 |
| Computer science | 31.2 | 26.8 |

### Bachelors

| | | |
|---|---|---|
| All fields | 57.6 | 60 |
| All STEM | 35 | 40 |
| All Social Science | 60 | 55 |
| Biology | 62.5 | 60 |
| Geoscience | 42.2 | 40 |
| Mathematics & statistics | 45.9 | 45 |
| Engineering | 20.5 | 20 |
| Computer science | 25.1 | 18 |

The data show two expected results. One is that the percentage of women in STEM fields is smaller than in non-quantitative occupations. The other expected result is that the percentage of women proceeding to doctoral degrees is smaller than the percentage at lower educational levels.

The 45—50% of doctorates earned by women are heavily concentrated in fields such as education, humanities, social science, and life science (Judy Touchton, Caryn McTighe Musil, and Kathryn Peltier Campbell, 2009, A Measure of Equity; Women's

Progress in Higher Education, published by the Association of American Colleges and Universities). The smaller percentages in STEM fields lead many women's organizations to blame male-dominated universities for not encouraging women to pursue careers in physical science, engineering, and mathematics.

Women also wanted courses in Women's Studies. These programs, under a variety of names developed rapidly in the late 1900s. The first two programs were established in 1970 at San Diego State University and the State University of New York at Buffalo. A short time later, the first Master's degrees were awarded by Sarah Lawrence College.

Now 487 colleges and universities offer programs in Women's Studies. They include schools that provide minors, four-year schools that offer BA degrees, and universities that offer MA and PhD degrees. We can find several reasons for the development of programs in Women's Studies.

One reason was that traditional history courses were almost entirely about men — kings, tyrants, battles, pioneers (wives not mentioned), explorers.

Another reason was the opportunity to increase the number of women on college faculties. Almost all courses in women's studies are taught by women, although a few men participate at some schools.

Perhaps the major reason for establishment of programs in Women's Studies was that women students wanted to be seen as something other than an attractive "body." They were tired of being thought of merely as sex symbols

What do the Women's Studies programs teach? A sampling of courses from different schools shows courses about: medicine and the female body; sex and gender in society; women writers; contributions of women to rebellions and other corrections of social ills; and feminist theories.

In an effort to inject studies of women into other areas, many courses are cross-listed with courses in other departments, such as Sociology, Geography, Communication Studies, Political Science, Religion, and English.

How much effect do women's studies programs have on colleges where they are taught? The answer depends, obviously, on who you ask. The statistics, however, are grim. Enrollments and degrees awarded are much lower in women's studies than in traditional disciplines such as history, sociology, and English.

Why are the enrollments low? That also depends on who you ask. Are students too traditional to think of new programs? Are students concerned that women's studies won't lead to jobs after graduation? Are both men and women students simply "put off" by the attitudes of faculty that teach women's studies? (A women professor in an English Department described faculty members in Women's Studies as "fierce.") Doubtless, different students have different reasons, and I could find no information on which reason is more important.

Because women are commonly regarded as "underprivileged," women's studies programs are commonly associated with programs on minorities and other disadvantaged people. They include African-Americans and Latin-Americans. This linkage seems

artificial in view of the greater economic prosperity of Anglo-American women than of any minorities.

Because women's studies inevitably bring up the issue of sex, they are also mingled with problems of lesbian, bisexual, gay and transgender (LBGT) people. The website www.campuspride.org discusses the problems that these people face. Most programs in women's studies offer courses about LBGT people. Some schools label these courses "queer" studies.

## My opinion

I am delighted that women are rejecting old curricula in home economics, but I am disappointed that those programs have been replaced by "family and consumer science." I am also sorry that women are not aiming more toward the STEM fields. By comparison, women's studies seem to be a rather "soft " program.

I think the responsibility for the situation falls about equally on women and men, and I assign a male culpability index of 5.

# 12. Now the Shoe is on the Other Foot, but which One?

Equity - n, fairness, impartiality

We have come a long way in the two centuries since colonial time.

Two hundred years ago, men were clearly in charge of society. They made all of the decisions, both personally and for the whole society. Women stayed at home to have babies, raise children, and obediently follow the laws that their husbands and men in government imposed on them.

Now women are mostly outside of their homes. More women than men go to college. Women fill professional jobs that used to be restricted to men. In some families, women are the principal source of income.

So it seems that women are now in charge of society. Or are they? We explore that question in this chapter, using the subheads: The Disappearance of Men, DNA and the Professions, Are American Children Raised by an Underclass of Women?, The Unisex Society - Equality and Equity; and An Observation from a Young Married Woman. We finish with my opinion of the situation.

# The Disappearance of Men

Nearly two thirds of college undergraduates are now women. Even such stalwart male bastions of science and engineering as Caltech and MIT are coeducational. In contrast to more than 50 women's colleges, only two men's colleges remain in the entire United States — Wabash in Indiana, and Hampden-Sydney in Virginia.

Many of the women undergraduates continue to graduate and professional work. Women are now 24% of America's lawyers, 27% of America's college professors, and 28% of America's doctors. We discuss educational achievements of women more completely in chapter 11.

With all of this education, what are American women doing? The Women's Bureau of the United States Department of Labor provides this summary for 2009:

"Of the 122 million women age 16 years and over in the U.S., 72 million, or 59.2 percent, were labor force participants—working or looking for work. Women comprised 46.8 percent of the total U.S. labor force.

"66 million women were employed in the U.S.—74 percent of employed women worked on full-time jobs, while 26 percent worked on a part-time basis.

"The largest percentage of employed women (40 percent) worked in management, professional, and related occupations; 32 percent worked in sales and office occupations; 21 percent in service occupations; 5 percent in production, transportation, and material moving occupations; and 1 percent in natural resources, construction, and maintenance occupations. "

The Women's Bureau also provides statistics on individual occupations. We divide them into four categories and show the percentage of women in those that require post-secondary education:

*Traditional Women's Occupations requiring Post-secondary School Education*
Registered Nurses: 92,0%
Elementary and Middle School Teachers: 81.9

*Traditional Women's Occupations NOT requiring Post-secondary School Education*
*(these positions are almost totally filled by women.)*
Secretaries and Administrative Assistants
Cashiers
Home health aides
Retail salespersons
Waitresses
Maids and Housekeeping Cleaners
Childcare workers
Bookkeepers
Receptionists and Information Clerks
Cooks
Office Clerks

*Traditional Men's Occupations requiring Post-secondary School Education*
Tax Examiners, Collectors, and Revenue Agents: 73.8%
Medical and Health Services Managers: 69.5%
Social and Community Services Mangers: 69.4%
Psychologists: 68.8%

Business Specialists: 68.4%
Human Resource Managers: 66.8%
Financial Specialists: 66.6%
Tax Preparers: 65.9%
Insurance Underwriters: 62.8%
Education Administrators: 62.6%
Accountants and Auditors: 61.8%
Veterinarians:: 61.2%
Claims Adjustors, Appraisers: 60.6%
Budget Analysts: 59.3%
Medical Scientists: 56.9%
Advertising and Promotion Managers: 56.5%
Financial Managers: 54.7%

*Traditional Men's Occupations NOT requiring Post-secondary School Education*
*(these positions are filled almost exclusively by men, and most of them require more physical strength than women possess.)*
Construction
Utilities Repair
Hauling of Freight, Garbage, etc.
Mining and other Resource Extraction
Police and Fire Departments
Fishing, Harvesting, and Logging

There are some jobs that probably will continue to be filled mostly by men. Most of those jobs require strength instead of education. Women will never play professional football or move furniture into and out of houses. But what about the jobs that require college or university education? The STEM fields (science, technology,

engineering, and mathematics) are still about two thirds male, but most jobs that require higher education are more than 50% occupied by women. Where have the men that used to fill those jobs gone?

Those absent men are not easy to find. The U.S. Bureau of Labor Statistics shows only a small number of highly educated men as unemployed in 2009 and 2010. The percentage fluctuates from month to month but centers at 4% to 5%, much smaller than the 10% to 12% unemployment for all men in the United States.

This low unemployment rate could have developed in three ways. One is that so few men have received the necessary education that there are jobs left over for women to fill even if nearly all of the men are employed. A second possibility is that educated men have taken jobs that do not require a high education, thus "dropping down" the employment ladder. A third possibility is that educated men have dropped out of the labor force and are not counted as "unemployed" because the Bureau of Labor Statistics counts a person as unemployed only if he/she is actively looking for work.

So if men are dropping, is it "down' or "out?" Do educated men who lose their jobs look for any work, or do they go home and let their wives (possibly even parents) take care of them? The statistics are blurry, but we should note that it is rare to encounter educated men in jobs that do not require an education. So, apparently men are dropping out instead of down.

Congratulations, ladies! You win! Educated men are scattered before your onslaught and fleeing for shelter.

With their wives. Their parents. Anyone who can offer refuge from the storm.

Do you feel good? Let's look at the next section while we think about that.

## DNA and the Professions

We start this discussion with a plea to both feminists and misogynists. PLEASE REMAIN CALM!

Different genes make women and men physically different. This obvious fact leads to two highly contentious questions about this difference. One is whether there are also emotional differences between women and men. For example, are women more attached to children than are men? Do women need support from other people more than men do?

If there are emotional differences, then we come to the second question. Are the emotional differences solely the result of the physical differences, or does the DNA of women make them more emotional than men in addition to making them physically different?

Let's ignore this philosophical conundrum and simply discuss the effect that children have on women's careers. They must cause at least a temporary interruption in careers no matter how much help women have at home for child care and other domestic duties.

Educated women have three choices for having children. One is not to have children. The Pew Research Center (pewsocialtrends.org/pubs) reports that about 25% of women aged 40—44 with Bachelor's degrees have not had children (and are now too old to become

pregnant). That figure contrasts with about 15% of women who did not go to college remaining childless.

Two other choices are available to women who want to have children and also have careers. One is to have children early, perhaps in their 20s, shortly after finishing their education. This choice lets women leave children with caregivers or at daycare centers as soon as the children are old enough, thus letting the women find jobs without facing the possibility of interrupting their careers later in life. This plan means that women start their careers later than men and may never catch up or go as far.

Most women, however, prefer to start their careers as soon as they leave school. This delays the choice between remaining childless or having children until later in life, generally their 30s. The results of deciding to have children are described in a 2008 report by the U.S. Census Bureau (www.census.gov/prod/2008pubs/ p70-113.pdf). Some of the results of starting careers early are:

— The percentage of first births that were to women aged 30 and over increased from 4% in 1970 to 24% in 2000.

— First births to women who had completed 4 or more years of college approximately doubled from 12% of all births in 1970 to 23% in 1990.

— Between 1960 and 2000, the percentage of all women who worked full time during pregnancy increased from 40% to nearly 60%. By 2000, 90% of educated women worked until 3 months before giving birth, and 67% until 1 month before giving birth.

The tendency for women to delay pregnancy led to numerous changes in state laws and at least 3 major new federal laws:

— In 1976 the federal tax code was changed to permit working families with a dependent child to take a tax credit for child care costs.

— In 1978, the Pregnancy Discrimination Act prohibited employment discrimination on the basis of pregnancy or childbirth. This act covered hiring and firing policies as well as promotions and pay levels.

— The Family and Medical Leave Act (FMLA) of 1993 requires employers to grant up to 12 weeks of unpaid leave for childbearing or family care over a 12-month period. (Many organizations that want to retain good employees exceed this requirement and grant paid leave to pregnant women.)

Why do most educated women want even a brief interruption of their careers in order to have children? Why do they wait until their thirties and have children just before their 'biological clock runs out at menopause? Most pundits seem to have concluded that women feel "unfulfilled" unless they bear children.

Let's avoid provocative words like "unfulfilled" and simply conclude that women like babies. Statistical evidence for this desire comes from a 2005 publication of the U.S. Department of Health and Human Services —

Chandra A, Martinez GM, Mosher WD, Abma JC, and Jones J. *Fertility, family planning, and reproductive health of U.S. women: Data from the 2002 National Survey of Family Growth. National Center for Health*

*Statistics. Vital Health Stat 23(25)*. This study showed that about 10% of U.S. married couples have been unable to have babies despite trying to have them. Medical examinations show that most of this difficulty arises because the wives are infertile. Consequently. more than 7% of women in childbearing years (ages 15 to 44) have had treatments to enhance fertility.

Hearsay evidence (gossip) supports this desire. Let's look at a miscellany of comments by educated women on Facebook (FB) or other parts of the web:

— "If I had known how much fun it is to hold a fussy, wet, wriggling baby, I would have had one earlier." (a post on FB from a woman well started on a professional career with an oil company)

— A woman working with an environmental company became a stay-at-home mother after the birth of her child and posts monthly information about her boy on FB.

— An Associate Professor in the early stages of her career posts videos on FB of her new baby as she stays home to care for him.

— An educated woman posted on the web "II I have to bother with a monthly menstrual cycle, I suppose I should have babies."

— Another educated woman posted "I didn't think I wanted children until my sister-in-law became pregnant. Then my desire for a child became overpowering."

If professional women continue their careers after having children, they and their husbands must make suitable arrangements for the care of their children. We consider this problem in the next section.

# Are American Children Raised by an Underclass of Women?

Women with professional careers must make arrangements for the care of their young children. The National Child Care and Technical Assistance Center (nccic.acf.hhs.gov/poptopics/statistics.pdf) publishes statistics about the types of child care that are commonly used. The data for **all**, not just professional, women show that about half of the child care comes from close relatives of the woman (parents, grandparents, siblings). Approximately one fourth of the care is in an organized child care facility (day care center, nursery, preschool, and Head Start). The other one fourth of child care is scattered among various options. The most common of these options is care in the provider's home or a family day care center. Only a small percentage of families can afford to have care givers come to their homes. The average care giver earns about $20,000 s year.

The costs of child care are summarized by the National Association of Child Care Resource and Referral Agencies (www.naccrra.org/docs/policy/breaking_the_ piggy_bank.pdf). The cost of child care varies by location and by the age of the child. In all locations, costs are higher for younger children (particularly infants) than for older children. Costs are particularly high in New York and other northeastern states and in Minnesota. Nationwide, the average cost of care for infants is in the range of $8,000 to $12,000, with the cost for older children about $1,000 lower.

Although the cost of child care is stressful for low-income families, it is well within the reach of professional women, particularly those in families where both husband and wife have professional jobs. Some of these families have joint incomes of $100,000 a year or more.

The difference between the incomes of professional women and the people who take care of their children raises the issue of fairness. Should women be paid only $20,000 a year to raise the children of relatively wealthy parents? Regardless of whether the difference is fair or not, it is clear that the women who actually raise children form an underclass of people who are paid much less than the parents of the children.

## The Unisex Society; Equality and Equity

Now that many women are doing the same jobs as men, have we become a society in which gender doesn't matter? Yes and no.

Men and women have obtained equality in some respects. The U.S. Social Security System used to give women slightly lower payments than men of the same age This difference was based on the actuarial fact that women lived longer than men, and thus women and men would receive the same total payments by the ends of their lives. Now Social Security payments are based solely on age, and women and men receive the same payments at equal ages.

Another example is from the world of sports. At grand slam tennis tournaments, men play matches in which they must win 3 out of 5 sets, but women play to win 2 sets out of 3. For this reason, men used to receive

higher prizes for winning, but now men's and women's prizes are equal.

Women also obtained equality with men in areas that didn't involve money. Until the 1960s, women in college residences had to obey parietal rules such as curfews and dress codes that never applied to men (Chapter 9). By 1970, however, these rules had almost completely disappeared from American colleges.

Educated women however, have not obtained salary equality with men in comparable positions. In 2006, women with professional degrees (MD, LLB, etc.) earned about 76% as much as men with similar educations, and women with PhD degrees earned about 70% as much. It is hard to know if this salary gap is caused by prejudice against women, or if it results from lack of seniority for women because they spent some time out of the labor force while they had children.

Here we must note that equality is not always the same as equity. We explore several examples to show how women and men must behave differently from each other. They include security, expenses for attracting the opposite sex, and "potty parity."

The problem of equality vs. equity involves security simply because women are physically weaker than men. All colleges and universities keep their campuses well lighted, have security phones at strategic locations, and provide escort services when women request them.

I remember that all resident students at Rice University in the 1960s paid the same fee for room, board, and security. When women complained that they should pay

less because hey didn't eat as much as the men, the men complained that they should pay less because they didn't need as much security as the women.

Attracting the opposite sex is far more important for women than for men. Women spend much more time and money making themselves attractive to men than men spend making themselves attractive to women. Comparative statistics are not definitive, but it is clear that women spend more than men on clothing and beauty aids.

Before distribution of the contraceptive pill in 1960 (Chapter 10), the extra money that women spent on themselves was offset by the money that men spent on women. That was a time when men took women out on dates and were responsible for their safety. Men bought dinner and movie tickets, and sometimes bought flowers or other presents. It was also a time when all wives took their husband's last names and when husbands became morally and legally responsible for the welfare of their wives and children.

That responsibility seems to have disappeared now (see Hanging out, Hooking up, and Looking for Mr. Right (Norval Glenn and Elizabeth Marquardt, An Institute for American Values Report to the Independent Women's Forum. 2001). Women still have higher costs of beautification, and they share costs with men when they go out ("hang out") together.

The contentious issue of "potty parity" arises because public places that have equal toilet facilities for women and men are apparently short-changing women. Men

can zip into a restroom, take a leak and zip out quickly. Women take extra time to remove some of their clothing. Because of this problem, it has been estimated that public places should have three times as many toilets for women as for men.

The legal complications of potty parity can be illustrated by a complaint filed with the U.S. Civil Rights Commission. It was filed against the University of Michigan by John F. Banzhaf III, Professor of Public Interest Law at George Washington Law School, Washington, D.C. The complaint alleges

*"1. the University of Michigan's renovations of its Hill Auditorium would provide insufficient rest room facilities for females as compared with males; 2. that this would place a much heavier burden on women who would be forced to wait — solely because of gender — in much longer rest room lines; 3. this disparate impact constitutes unlawful gender discrimination unless it can be affirmatively justified by business necessity; 4. it may also violate the Equal Protection clause of the U.S. Constitution unless the significant disparity in waiting times is substantially related to a sufficiently important governmental interest; 5. this Office, under at least two U.S. Court of Appeals decisions and several additional authorities, has jurisdiction over these issues; 6. therefore your Office should at the very least determine that it has jurisdiction over the general issue and initiate a formal investigation so as to: A. allow the University of Michigan to be heard formally B. explore with more precision, and with more detail than is possible in an initial complaint, the underlying factual issues such as the*

*number, location, placement, etc. of different restroom facilities, evidence relating to male and female waiting time both historically at the Hill Auditorium and more generally given different ratios of men's and women's toilet facilities, etc. C. permit the University to present whatever evidence and arguments it might wish to make regarding the legal key issue of "business necessity" D. build a record appropriate for eventual judicial review on both the statutory and constitutional issues which are raised."*

Some public places, including several colleges and universities, have tried to solve the parity problem by having unisex restrooms, used by both women and men. These efforts have also led to personal and legal complications. Nobody objects to single-stall restrooms that are occupied by one person at a time. Many people, both women and men, however, object to restrooms that contain several stalls. Facebook ran a survey to determine student attitudes toward unisex restrooms and received posts like the following:

— *I'm a 19 yr old heterosexual female and i wouldn't mind using a unisex bathroom...but I could see many problems involving unisex bathrooms in a university... horny teenagers for one...I could see a higher risk of rape or sexual assault...Bathrooms may be not clean...i don't know if guys would be comfortable with girls' menstrual cycles.*[spelling and punctuation modified]

— *A male said "Most of the posts here say that people "wouldn't mind" but who would prefer it?"*

Some schools have built unisex restrooms because they interpreted them as a proper response to federal and state that prohibit discrimination against people who are transgender gay, lesbian, and bisexual.

# An Observation from a Young Married Woman

This comment from a friend who is a young married mother neatly summarizes the problems faced by women in the early 21st century. With her permission, I copy it verbatim except for removing names of people and places that could identify her.

*I thought I would share what is happening to one woman who delayed childbirth until completing graduate training. I had a job; now I am [my son's] caregiver. Yes, I am a stay-at-home mom. Not at all what I anticipated after graduate school. There are still serious gender biases in our society that will be too difficult to eliminate. I was off work 5 ½ months with 4 weeks of 60% pay which was provided by my company's short term disability policy. This was generous. We were fortunate that [my husband] was doing well enough that I could take 5 ½ months. I returned only part-time (20 hours) because I wanted to nurse [my son]. I really think women should be hugely supported in this activity. (If we did away with formula we could seriously reduce childbirth rates for some segments of the populace, too) I will say that my employer had dedicated a room off the kitchen for all of us who were pumping (the company had 6 on maternity leave at one point). Yes, this is a*

*weird bonding experience that I guess men in business would like to pat themselves on the back for being so progressive. It's weird. No two ways about it. Nursing a baby with other women together is normal; listening to 2-cycle motors (dual action) pumping away in a room with NO babies is strange. It feels like a milking parlor and very industrial.*

*At 20 hours I felt connected to work and had the desired time to be with [my son]. But this was very hard for management to manage. I got moved around a lot on projects because they really didn't know how to fit me in at 20 hours. Eventually I didn't see any interesting projects coming along (e.g., we lost a couple big proposals) and I was needing to take on more oversight for my mother's care. After much deliberation, I left last October. I kept [my son] in daycare for about 3 extra months while I kept looking for something related to [my field of] research here, but I found nothing substantial going on that would have been easy to break into.*

*So what I am doing today? Caring for my child and looking after my mother's affairs, not gainfully employed. Is this any different than things where 100 years ago? I am thankful for my education. It can never be taken away from me. I do worry about what happens next once [my son] is in school. I recall seeing this commercial on PBS. It shows people walking across a desert and the voice says "there's a resource more powerful then..." Eventually you realize the people are women and it's an ad for some NGO raising awareness about the importance of women in society. While the ad is about*

*the developing world I've often felt that the same could be said for this country, or the West in general. We're not as different as we like to think. Am I being socialist? Don't get me wrong. [my husband] is a wonderful husband and a terrific father. He's worked very hard to get were he is. He's also lucky that he's got training that he can market without a lot of competition. It sometimes just feels like men get to have the ideas about how things should be and now-a-days it's women who do the executing, for little pay or recognition.*

## My Opinion

Educated women have now gained equality with, or surpassed, men in many jobs and in many levels of education. They do not have equity, however. Women are commonly paid less than men in comparable jobs, and they must do their jobs while paying more attention to security and personal appearance than men.

In addition to these extra duties, women must also perform the innate duties of women, including bearing children, raising children, managing households, and caring for their husbands.

The extra burdens have been placed on women because men no longer fill their traditional roles of providing security for women and earning income to support their families.

Consequently, the decisions made by men control, by default, the way in which American society operates. For this reason, I assign a male culpability index of 9 to the situation in the early 21st century.

# General index

Leary, Timothy 175
Lease, Mary  144
Litchfield Academy 50, 51
LSD (acid) 175
Lundgren, Frederick  152
Lyman, Hannah59, 60
Lyon, Mary 59
Marijuana (pot) 174, 175
Matches 33
Mills, Cyrus and Susan 123
Moravians 27, 29
Morrill Land Grant 31, 36, 129, 130
Newcomb, Josephine Louise 81, 82
Pasteurization 35
Physical education for women 43, 44, 46
Pickling 17
Pitcher, Molly  23
Potty parity 295, 207
Pound, Louise 144
Pregnancy Discrimination Act 201
Prostitute root  20
Quantrill's  raid 118
Refrigeration 34
Richards, Ellen Swallow 49. 50, 141
Root cellars 17
Routt, Eliza Pickrell 119
Running 45, 60
Seneca Falls Declaration 46, 47, 48, 143
Smith, Sophia  61
Snell, Margaret Comstock  127
Soap 18
Stanton, Elizabeth Cady 48

# School index

# Would you like to see your manuscript become a book?

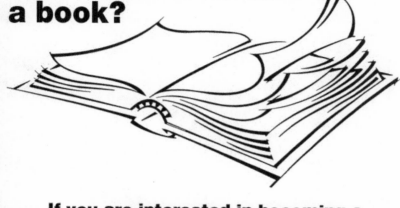

If you are interested in becoming a PublishAmerica author, please submit your manuscript for possible publication to us at:

**acquisitions@publishamerica.com**

You may also mail in your manuscript to:

**PublishAmerica
PO Box 151
Frederick, MD 21705**

# www.publishamerica.com